Rock & Roll
for Everybody
A Photographic Tour of Today's Bands

Steven Sanchez

AMHERST MEDIA, INC. ■ BUFFALO, NY

ACKNOWLEDGMENTS

I would like to thank my father, Daniel, and my mother, Beatrice, who showed me that rock 'n' roll was something to dream about. Additional thanks to: my twin sister, Stefani, my most honest critic and biggest supporter; my aunt and uncle, who bestowed me with their records which began the dream; both of my grandparents on both sides for their loving support. Thanks to all my friends who never doubted my goals, no matter how far-fetched they sounded. Finally, thank you to my hometown of Fresno; dreams do come true in the most unlikely places, even if it's in your backyard.

Published by:
Amherst Media, Inc., P.O. Box 538, Buffalo, N.Y. 14213
www.AmherstMedia.com

Publisher: Craig Alesse
Publisher: Katie Kiss
Senior Editor/Production Manager: Michelle Perkins
Editors: Barbara A. Lynch-Johnt, Beth Alesse
Acquisitions Editor: Harvey Goldstein
Editorial Assistance from: Carey A. Miller, Rebecca Rudell, Jen Sexton-Riley
Business Manager: Sarah Loder
Marketing Associate: Tonya Flickinger

ISBN-13: 978-1-68203-418-7
Library of Congress Control Number: 2019932348
Printed in The United States of America.
10 9 8 7 6 5 4 3 2 1

www.facebook.com/AmherstMediaInc
www.youtube.com/AmherstMedia
www.twitter.com/AmherstMedia
www.instagram.com/amherstmediaphotobooks

AUTHOR A BOOK WITH AMHERST MEDIA

Are you an accomplished photographer with devoted fans? Consider authoring a book with us and share your quality images and wisdom with your fans. It's a great way to build your business and brand through a high-quality, full-color printed book sold worldwide. Our experienced team makes it easy and rewarding for each book sold—no cost to you. E-mail **submissions@amherstmedia.com** today.

Contents

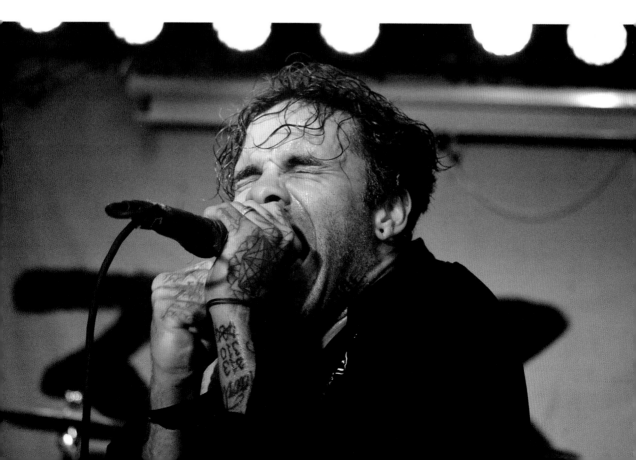

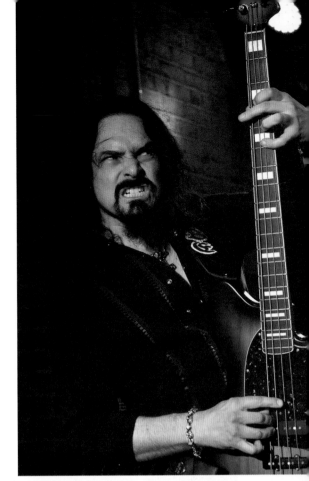

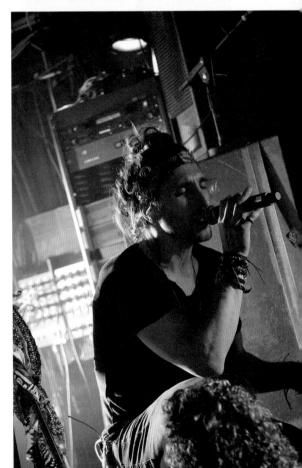

About the Author

MORE AT

www.instagram.com/stevensanchez5807/

www.facebook.com/steven.sanchez.12177

In 2015, Steven Sanchez (a film graduate of the University of Nevada, Las Vegas) sought employment at a local rock radio station in his hometown: the agricultural city of Fresno, California. He was tasked to attend and take pictures of rock concerts on behalf of the station. Growing up as a rocker his entire life this was a dream come true. That responsibility turned into a personal endeavor and obsession, to where he made it a mission to cover all the top bands that came to the Central Valley.

From 2016 and onward, when any prominent band passed through, chances are he was there, front row center, snapping away. He documented concerts by Shinedown, The Deftones, Ghost, A Day To Remember, Trapt, Starset, Smash Mouth, Highly Suspect, Radkey, Collective Soul, 3 Doors Down—and the list goes on. Through that time, he came to the realization that no one had ever commemorated or archived the great artists that have performed in his hometown. And that's the reason for the existence of this book.

His photographs and music articles are published in local publications such as *Kings River Life Magazine* and *Fresno Flyer*. He continues to do concert photography, looking for the next great show to capture in an image. He resides in Clovis, California.

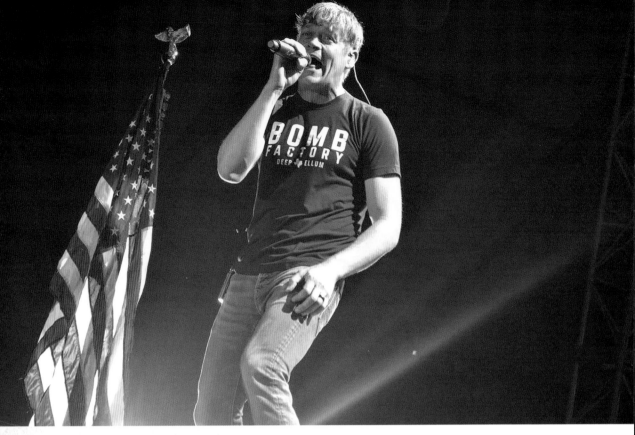

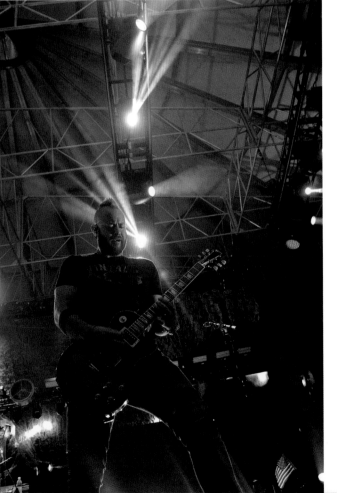

3 DOORS DOWN

Tachi Palace in Lemoore, CA | September 6, 2018

ABOVE—This band's music meant a lot to me in high school. Their songs were played at dances and parties. If you choose to pursue concert photography, I suggest subjects whose music you have a passionate connection with. *(Brad Arnold, lead vocals. Nikon D3200, f/5.6, 1/125 second, 55mm, ISO 1600)*

LEFT—When photographing big concerts, the stage lighting pointing directly at you can cause glare on your, resulting in the image being engulfed by a whole ball of light. But at the right time, like this one, it can capture the vastness of a live production. *(Chet Roberts, guitar. Nikon D3200, f/3.8, 1/125 second, 20mm, ISO 1600)*

"Depending how you position the camera, their eyes can speak the loudest."

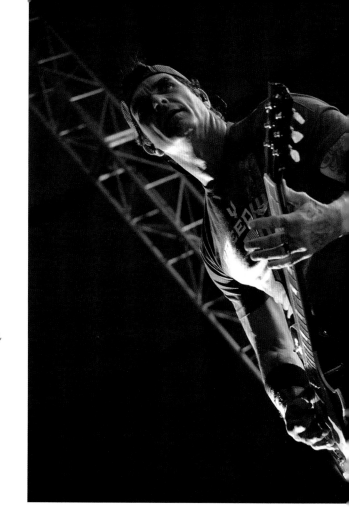

RIGHT—The best thing about getting lower angle shots like this one is that you make the musician look larger than life. *(Chris Henderson, rhythm guitar. Nikon D3200, f/3.8, 1/125 second, 20mm, ISO 1600)*

BELOW—A good portion of concert photos show the musicians looking at their instruments. Depending on how you position the camera, their eyes can speak the loudest. Like this—what is he looking at? *(Justin Biltonen, bass. Nikon D3200, f/3.8, 1/125 second, 20mm, ISO 1600)*

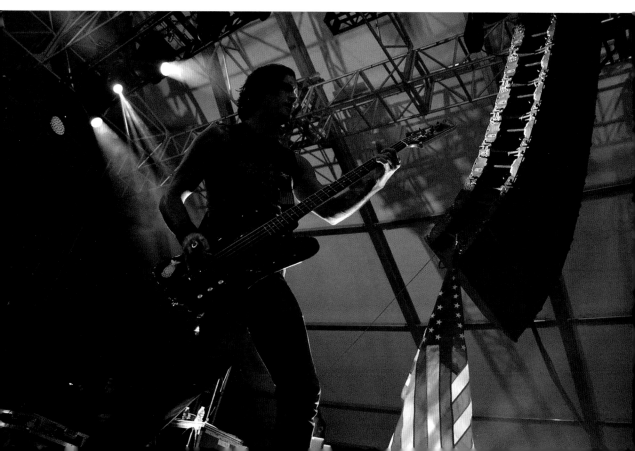

A DAY TO REMEMBER

*Woodward Park Rotary Amphitheatre
in Frenso, CA | July 19, 2017*

ABOVE—The band was playing the game KanJam before their concert. It's very interesting to catch people doing things that they're not known for. With musicians, capturing them doing something non-music related is always fascinating. *(Jeremy McKinnon, lead vocals. Nikon D3200, ƒ/8, 1/500 second, 55mm, ISO400)*

BELOW—Joshua calling his shot like Babe Ruth. Getting into the game. *(Joshua Woodward, bass. Nikon D3200, ƒ/8, 1/500 second, 55mm, ISO400)*

FACING PAGE, TOP—Jeremy smiling at me. I hope I'm not in the middle of his game. *(Jeremy McKinnon, lead vocals. Nikon D3200, ƒ/8, 1/500 second, 38mm, ISO400)*

FACING PAGE, BOTTOM—Joshua about to throw the frisbee. *(Joshua Woodward, bass. Nikon D3200, ƒ/8, 1/500 second, 55mm, ISO800)*

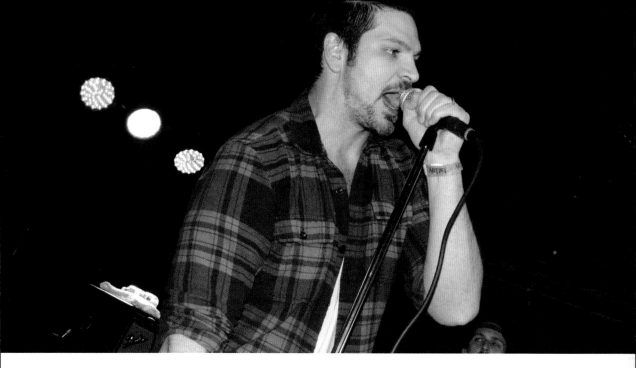

ADELITA'S WAY

Strummer's in Fresno, CA | January 26, 2017

FACING PAGE, TOP—It's a plus to capture your subjects doing something they're passionate about. It shows on their faces, resulting in an image that's filled with the same passion. *(Zack AttAkk, guitar. Nikon D3200, f/10, 1/160 second, 35mm)*

FACING PAGE, BOTTOM—Looking like he owns the place, the stage is his throne. Body language is always an essential to capture because it evokes emotion in the viewer. *(Rick DeJesus, lead vocals. Nikon D3200, f/10, 1/80 second, 44mm)*

THIS PAGE, TOP—The band originates from Las Vegas, where I went to college. I have to support bands from where I have roots. *(Rick DeJesus, lead vocals. Nikon D3200, f/10, 1/160 second, 35mm)*

ABOVE—The image is blurry but colorful. I like the way it creates a light trail effect that you see in traffic photography. Sometimes, blurring or light trails create a compelling photo. *(Zack AttAkk, guitar. Nikon D3200, f/10, 1/10 second, 18mm, ISO800)*

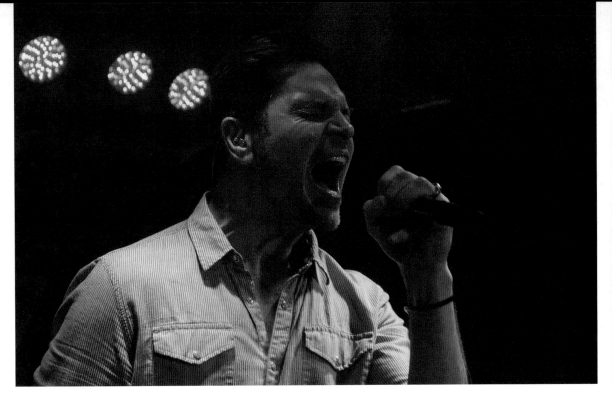

ABOVE—Rick hitting the high vocals. When you see a band multiple times, you get to know their songs and understand the choreography of their performance so you can master your shots the next time. I encourage you to see a band as often as you can to perfect how you capture them. *(Rick DeJesus, lead vocals. Nikon D3200, ƒ/5.6, 1/100 second, 55mm, ISO3200)*

BELOW—Drummers are pretty hard to capture during a performance. They're in the background (behind the rest of the band) and the spotlight isn't usually on them. When the lighting is just right, try to obtain that one-in-a-million shot. *(Trevor "Tre" Stafford, drummer. Nikon D3200, ƒ/4.2, 1/125 second, 82mm, ISO3200)*

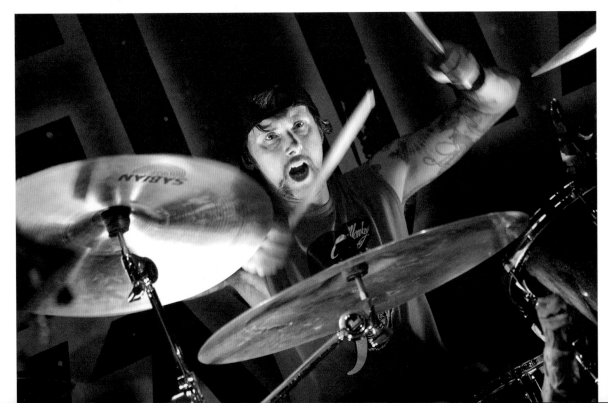

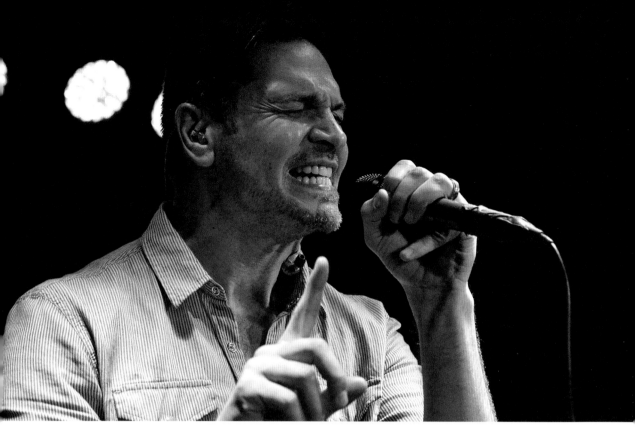

ABOVE—Why do I like black & white? Some lighting colors (like red, purple, and green) don't record well in photographs. But in black & white, it's all the same—and it makes it more epic. *(Rick DeJesus, lead vocals. Nikon D3200, f/4.2, 1/125 second, 62mm, ISO3200)*

RIGHT—I grew up reading *Rolling Stone* and watching VH1's *Behind The Music*—and they would show old photos, which were always monochrome. For me, that was the defining look of rock 'n' roll and I wanted to incorporate it into my style. *(Guitarist. Nikon D3200, f/4, 1/160 second, 24mm, ISO3200)*

"For me, that was the defining look of rock 'n' roll . . ."

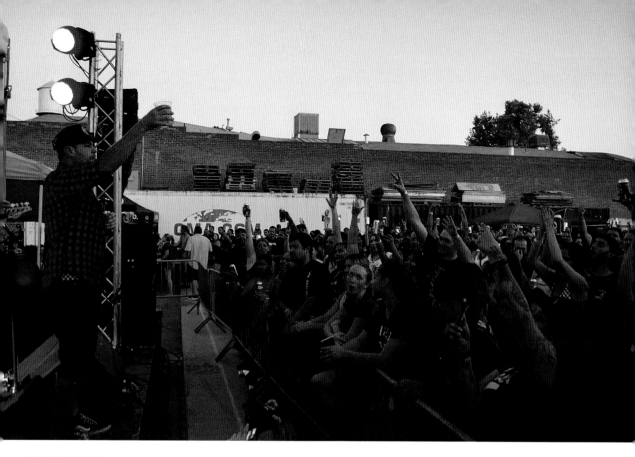

ALIEN ANT FARM

Full Circle Brewing Co. in Fresno, CA | September 8, 2018

FACING PAGE, TOP—The lower you get, the larger you make them seem. And for a brief moment, they are. *(Dryden Mitchell, lead vocals. Nikon D3200, f/4, 1/320 second, 18mm, ISO1600)*

FACING PAGE, BOTTOM—Outdoor shows provide the natural light you need to snap away. *(Terry Corso, guitar. Nikon D3200, f/4, 1/250 second, 18mm, ISO800)*

TOP—A performer interacting with the crowd makers for a keeper image. Here, singer Dryden Mitchell is giving a cheers to the crowd—and they toast him right back. I couldn't have chosen a better scene. *(Dryden Mitchell, lead vocals. Nikon D3200, f/4, 1/200 second, 18mm, ISO1600)*

ABOVE—Showing a musician become one with his or her instrument is a winning shot. That kind of connection can be just as appealing as a couple's photograph—because the connection and relationship that comes out of that passion is astounding. *(Tim Peugh, bass. Nikon D3200, f/5.3, 1/320 second, 40mm, ISO1600)*

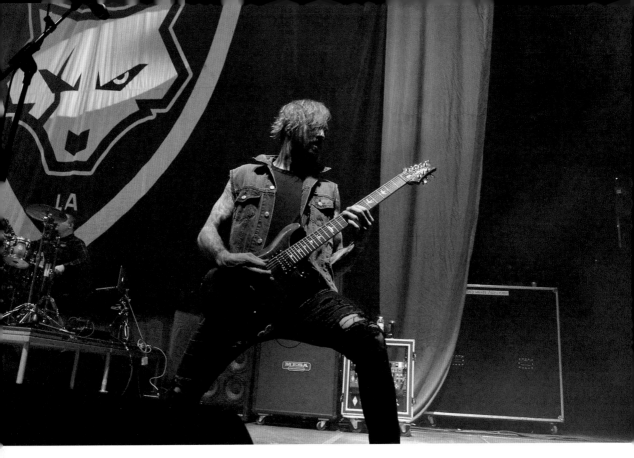

"Legs spread, hair covering half of the face, wailing away on his guitar. It's a classic rock pose."

BAD WOLVES

Save Mart Center in Fresno, CA | November 12, 2018

ABOVE—Legs spread, hair covering half of the face, wailing away on his guitar. It's a classic rock pose. *(Chris Cain, rhythm guitar. Nikon D3200, f/4, 1/160 second, 18mm, ISO 1600)*

LEFT—This is as close to a POV shot you're going to capture, showing what the singer sees from onstage. *(Tommy Vext, lead vocals. Nikon D3200, f/4, 1/160 second, 18mm, ISO 1600)*

RIGHT—There's something grand about shooting in an arena. It automatically comes with a heightened scale. No matter the angle, when it's at an arena, the scope of the environment can be felt just by looking at it. *(Kyle Konkiel, bass guitar. Nikon D3200, f/4, 1/160 second, 18mm, ISO 1600)*

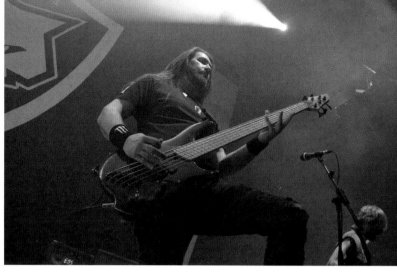

BELOW—Black & white photography transports us back to the basics. It's up to the viewer to fill in the blanks. What colors were really there? When did this take place? What was the subject thinking when the photograph was taken? Put your imagination to use. *(Doc Coyle, lead guitar. Nikon D3200, f/5.3, 1/160 second, 45mm, ISO 1600)*

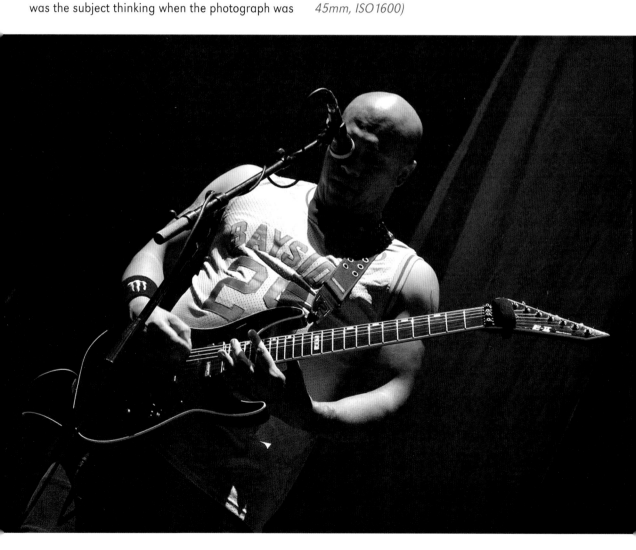

BARNS COURTNEY

*Tioga Sequoia Brewing
Co. in Fresno, CA |
December 11, 2018*

TOP LEFT—It's a relief to cover a solo, acoustic set. Your primary focus is just one person and you don't have to travel around a big stage to get the "right" shot. Anywhere is basically good. *(Nikon D3200, f/4.8, 1/125 second, 32mm, ISO 1600)*

BOTTOM LEFT—This was a free show—and if you're an aspiring photographer and you hear "free," that's an open invitation for you to practice your craft by taking the best photos you can and getting better from there. *(Nikon D3200, f/4, 1/160 second, 55mm, ISO 1600)*

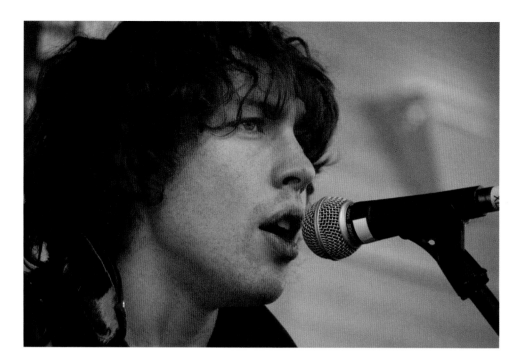

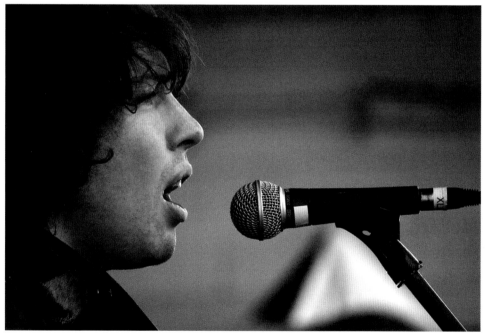

TOP—A close-up of the face is worth a thousand words. *(Nikon D3200, f/4.8, 1/160 second, 120mm, ISO1600)*

BOTTOM—Sometimes, a direct portrait of the face isn't interesting. We've seen plenty of those. Photographing the side of the face instead can raise interest. Also, it just looks cool. I like that it looks as if he and the microphone are having a stare down—boxing match style. *(Nikon D3200, f/5.3, 1/250 second, 175mm, ISO3200)*

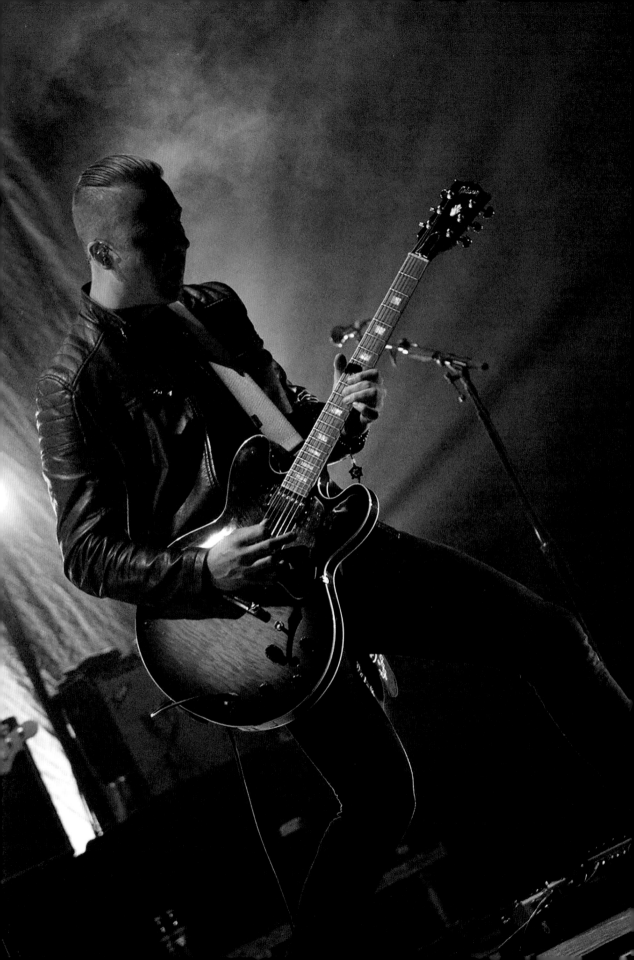

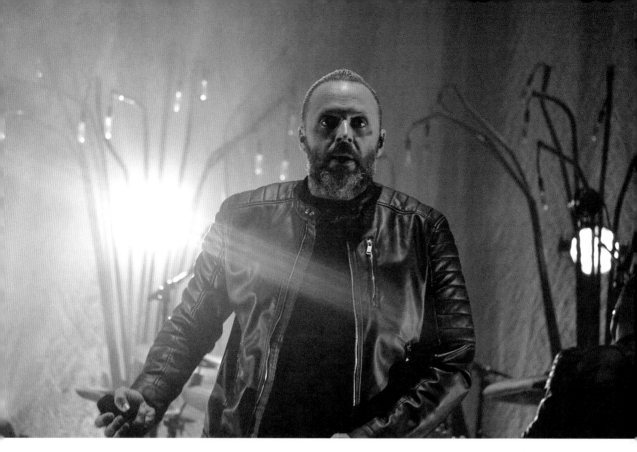

BLUE OCTOBER

Warnors Theatre in Fresno, CA | June 17, 2018

FACING PAGE—When you shoot a vertical image, you get the whole body in the frame. The focal length at this angle will bring your subject forward and help keep the viewer's focus on that person. *(Will Knaak, lead guitar. Nikon D3200, f/4.2, 1/200 second, 72mm, ISO3200)*

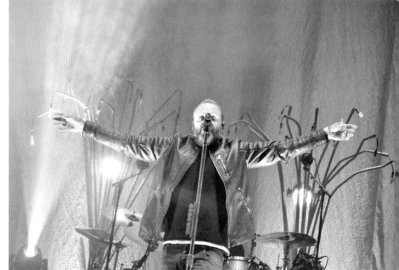

TOP—This band was very popular when I was in high school, so that adds a level of pleasure to what I do. I get to relive good memories every now and then. *(Justin Furstenfeld, lead vocals. Nikon D3200, f/4.8, 1/160 second, 116mm, ISO3200)*

ABOVE—Arms spread, like he's flying. Fun fact: Justin is friends with *Twilight* series author Stephenie Meyer. Blue October's music helped inspire her to write the books. *(Justin Furstenfeld, lead vocals. Nikon D3200, f/4.2, 1/100 second, 85mm, ISO3200)*

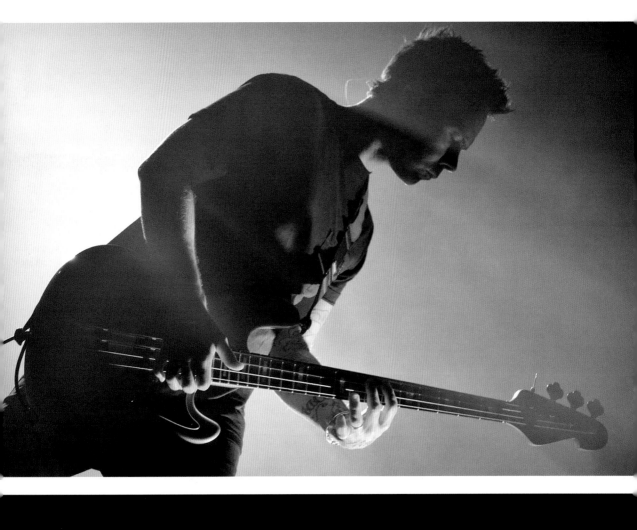

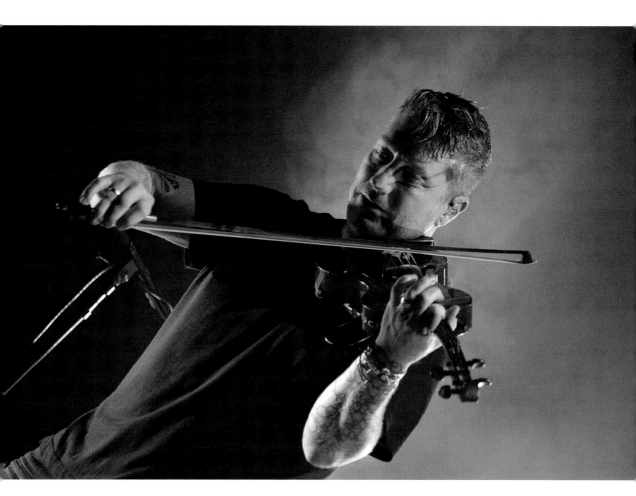

FACING PAGE, TOP—Sometimes clarity isn't a big deal. I like shots like this, half silhouette and half distinct. It's like a gothic shot from a classic film. Your images can go beyond the visual limitations of just the stage—they can be cinematic. *(Matt Noveskey, bass guitar. Nikon D3200, f/4.2, 1/125 second, 86mm, ISO3200)*

FACING PAGE, BOTTOM—Justin has suffered with depression and anxiety, and he uses music as a catharsis. It's very special when you see an artist use music for spiritual and deeper means. When you capture that in an image, then it goes beyond a regular photo. *(Justin Furstenfeld, lead vocals. Nikon D3200, f/4.2, 1/200 second, 72mm, ISO3200)*

ABOVE—With a short focal length (wide-angle lens), the surrounding environment will be included in the photo and the depth of field will be deeper, meaning that the subject will be more distinct. *(Ryan Delahoussaye, violin/mandolin/keyboard. Nikon D3200, f/5, 1/125 second, 125mm, ISO3200)*

"When you capture that in an image, then it goes beyond a regular photo."

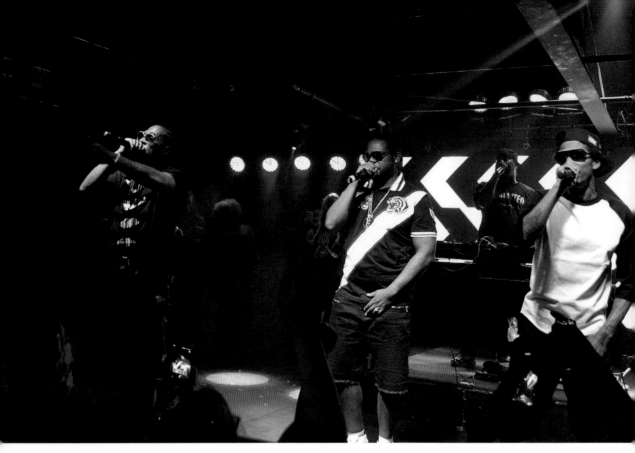

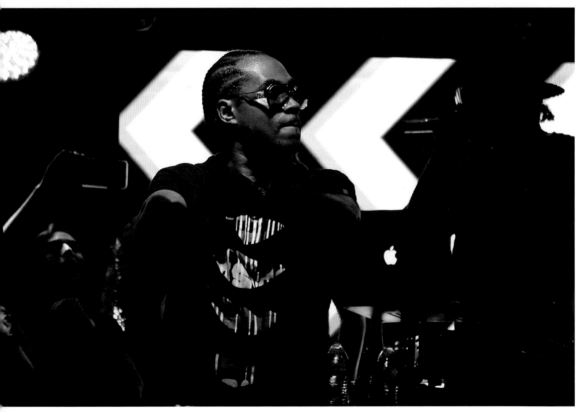

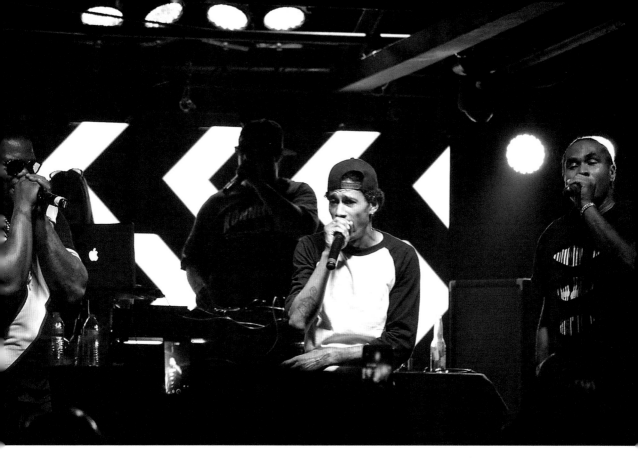

BONE THUGS-N-HARMONY

Strummer's in Fresno, CA | June 8, 2018

FACING PAGE, TOP—I mostly do rock shows, but it's always good to add some genre diversity to the mix. *(Nikon D3200, f/4, 1/60 second, 24mm, ISO3200)*

FACING PAGE, BOTTOM—Rockers usually don't dance around much, but hip hoppers use movement in their performance and can often dance well—so it does become imperative for you to capture that. *(Nikon D3200, f/5.3, 1/100 second, 175mm, ISO3200)*

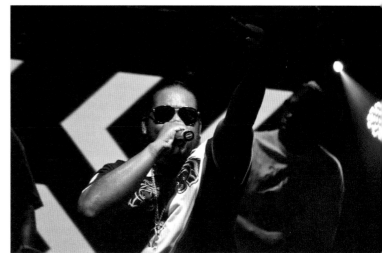

they feel. *(Nikon D3200, f/4.5, 1/100 second, 100mm, ISO3200)*

TOP—The cool thing about rappers is that they don't hide behind any instruments. This allows them to use their mouths as their instruments and use hand gestures and movements to express how

ABOVE—Flipping off the crowd. Not the nicest gesture, but it does represent the hip hop attitude. *(Nikon D3200, f/5.6, 1/100 second, 200mm, ISO3200)*

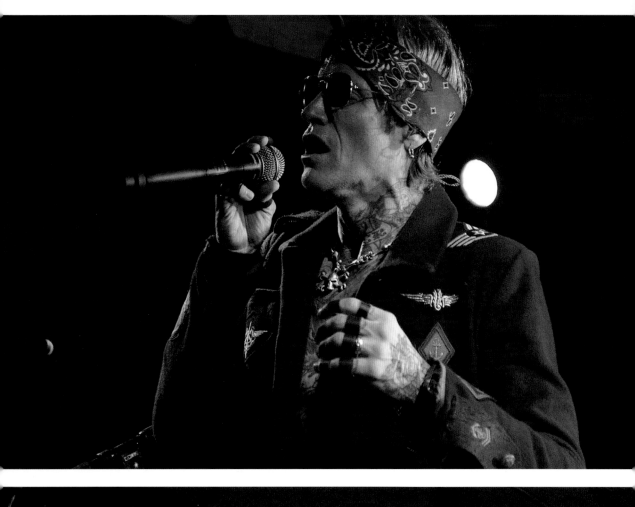

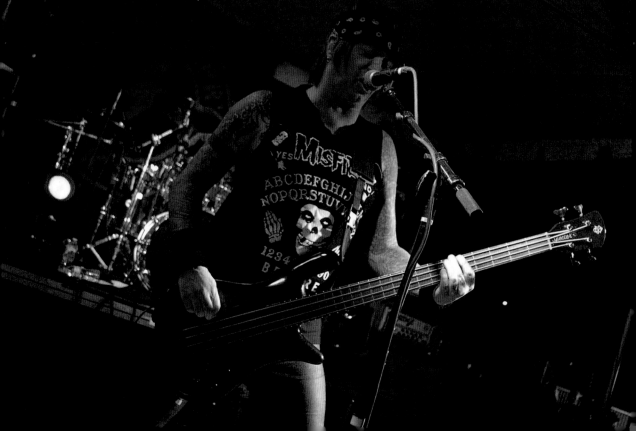

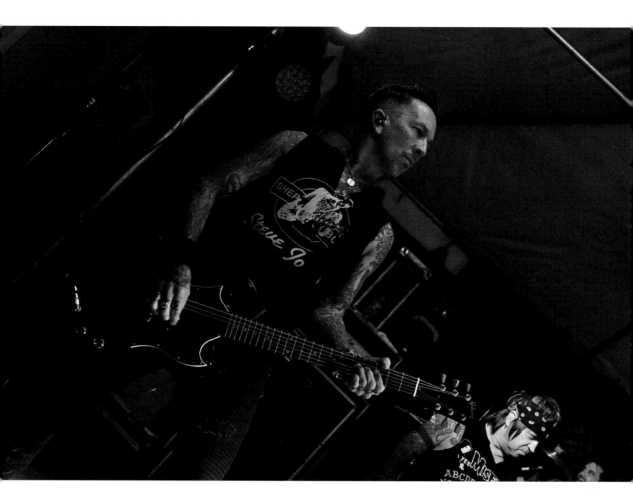

BUCKCHERRY

Full Circle Brewing Co. in
Fresno, CA | June 8, 2018

FACING PAGE, TOP—Tattoos, sex appeal, and dirty lyrics—Josh Todd is the epitome of what a rock singer is supposed to be. *(Josh Todd, lead vocals. Nikon D3200, f/5.6, 1/320 second, 55mm, ISO 1600)*

FACING PAGE, BOTTOM—Hey, bass players need love, too. That's a cool thing about band photography: you can give every member their moment in the spotlight. *(Kelly LeMieux, bass. Nikon D3200, f/4.5, 1/125 second, 29mm, ISO 1600)*

ABOVE—Be cautious while using black & white outdoors—especially at night. You're relying on the light source to bring some shine into the picture so patience is the key here. *(Kevin Roentgen, guitar. Nikon D3200, f/4.5, 1/400 second, 30mm, ISO 1600)*

"Tattoos, sex appeal, and dirty lyrics—Josh Todd is the epitome of what a rock singer is supposed to be."

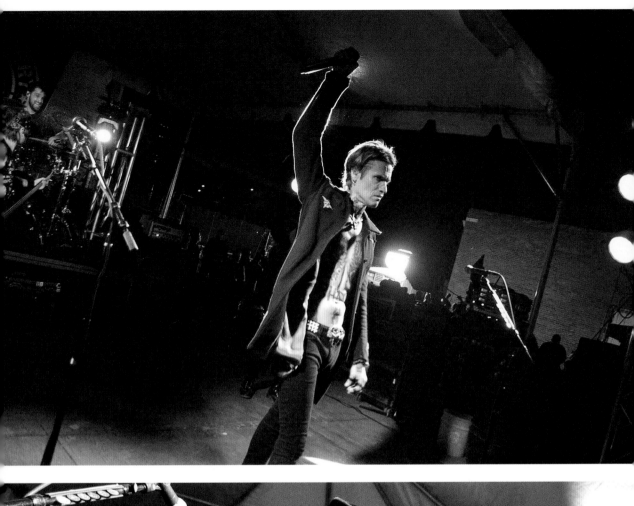
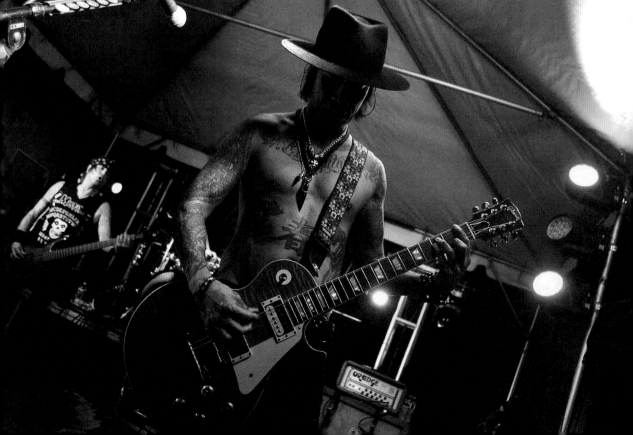

"The genre was created to break the rules. So, when it comes to concert photography there's no need to abide by any particular guidelines."

FACING PAGE, TOP—Josh Todd putting his arm in the air with the microphone in his hand. It may not have the best clarity, but the pose gives the image some character. (Josh Todd, lead vocals. Nikon D3200, ƒ/3.5, 1/125 second, 18mm, ISO 1600)

FACING PAGE, BOTTOM—With modeling photography and movies, they try to hide tattoos. I, on the other hand, prefer it—and in rock 'n' roll, it's almost a requirement. Tattoos add character to the musician and image. When you see the image, your focus gravitates toward the tattoos. (Stevie D., guitar. Nikon D3200, ƒ/3.8, 1/320 second, 22mm, ISO 1600)

BELOW—Rock 'n' roll is imperfect. The genre was created to break the rules. So, when it comes to concert photography, there's no need to abide by any particular guidelines. Embrace that fact. Catching a performance picture is like writing a hit song: you never quite know if it will work, but when it does it feels good. (Kevin Roentgen, guitar. Kelly LeMieux, bass. Nikon D3200, ƒ/4.5, 1/125 second, 29mm, ISO 1600)

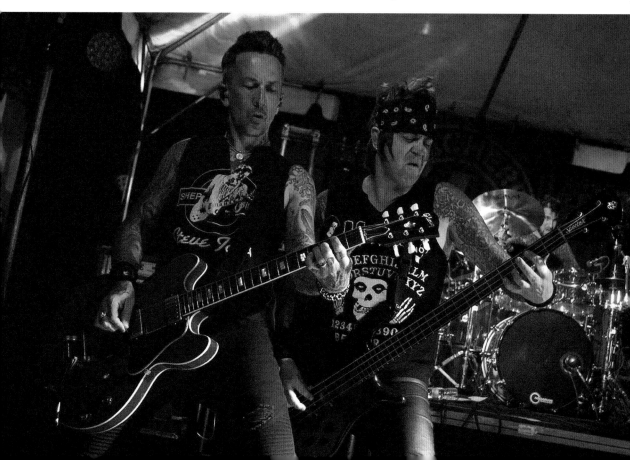

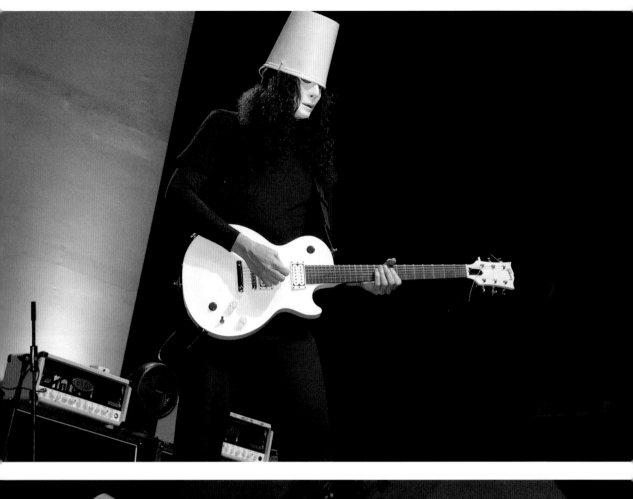
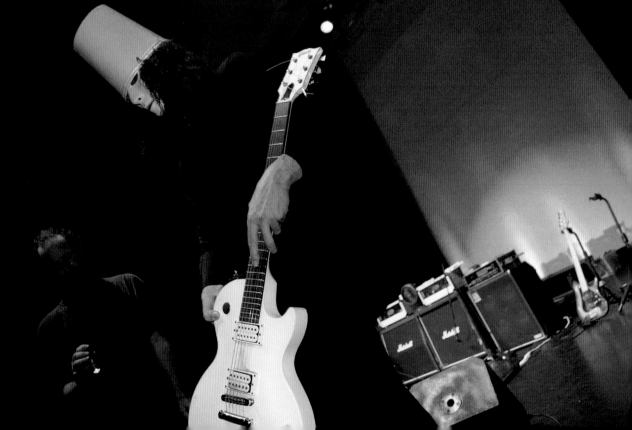

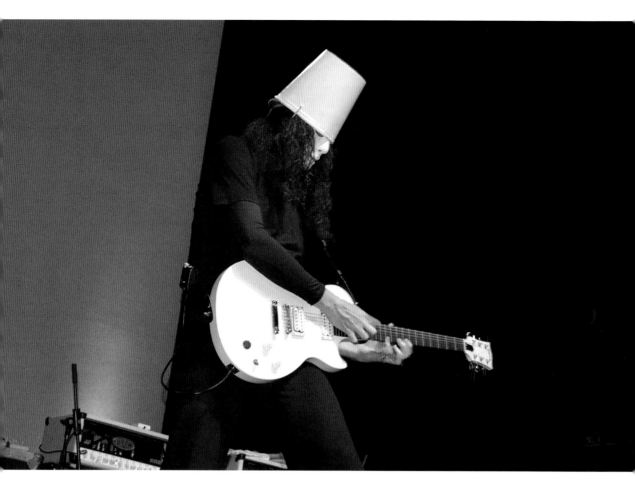

BUCKETHEAD

Tower Theatre in Fresno, CA | June 23, 2016

FACING PAGE, TOP—Brian Patrick Carroll, known professionally as Buckethead, is considered one of the greatest and most experimental guitar players of all time. Don't let the mask and bucket fool you. *(Nikon D3200, f/5.6, 1/60 second, 55mm, ISO3200)*

FACING PAGE, BOTTOM—This guy let people play and touch his guitar. I hadn't seen anything like that. That's why being a photographer is such an important role: you can document moments like this. *(Nikon D3200, f/3.5, 1/80 second, 18mm, ISO3200)*

ABOVE—Greatness comes in many shapes and sizes. I don't care that this guy talks through a creepy-looking puppet mask in interviews. He's great on stage and looks great in photographs. *(Nikon D3200, f/5.6, 1/15 second, 55mm, ISO800)*

BELOW—Seeing people's reactions to letting them play and touch his guitar is priceless. *(Nikon D3200, f/3.5, 1/25 second, 18mm, ISO3200)*

CITIZEN ZERO

Fulton 55 in Fresno, CA | August 24, 2016

TOP LEFT—This is one of the first bands I shot. It was doing shows like these that made my interest in this endeavor grow. *(Kodak Z650, f/2.8, 1/60 second, 6.3mm, ISO100)*

BELOW—Being unobtrusive is the key to capturing subjects in a natural state. Being inconspicuous helps a great deal. Yeah, you'll be the one with the big camera and closest to the stage, but the more understated you are with your camera, the better the images will be. Anonymity can lead to the photographs that speak the loudest. *(Kodak Z650, f/3.2, 1/80 second, 11.1mm, ISO80)*

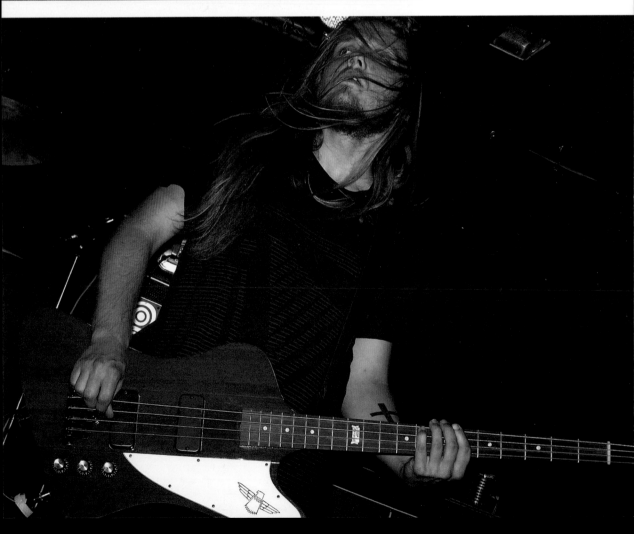

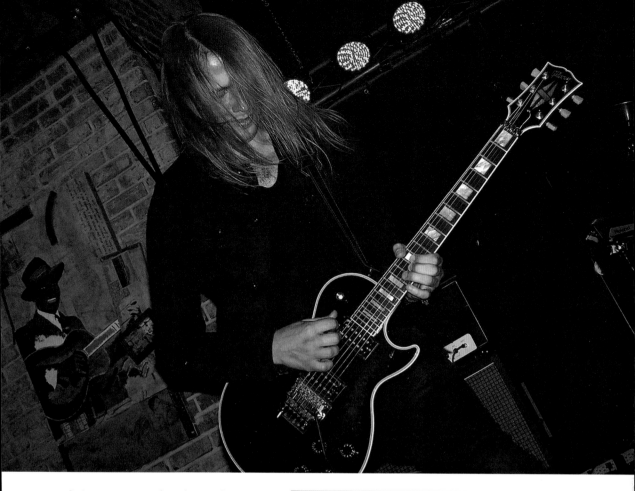

ABOVE—Strive to grow and evolve, making progress that is visible in your photos. These images were taken as I was just starting out. Can you see all the light coming from the flash? That's a no-no and thankfully the musicians here were cool about it. But as time goes on, your photos will reveal how far you've come as a photographer. *(Kodak Z650, f/3.1, 1/60 second, 9.3mm, ISO80)*

RIGHT—People usually say you don't want to meet your idols—but every now and then you meet high-profile people who are really just regular humans underneath their celebrity facade. These guys were very down-to-earth. We talked about football, how they liked California, and made all the regular chit chat. Humility still does

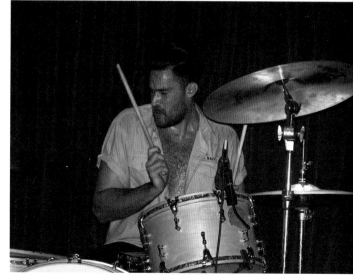

exist among these prominent personalities. *(Kodak Z650, f/3.2, 1/100 second, 21.2mm, ISO160)*

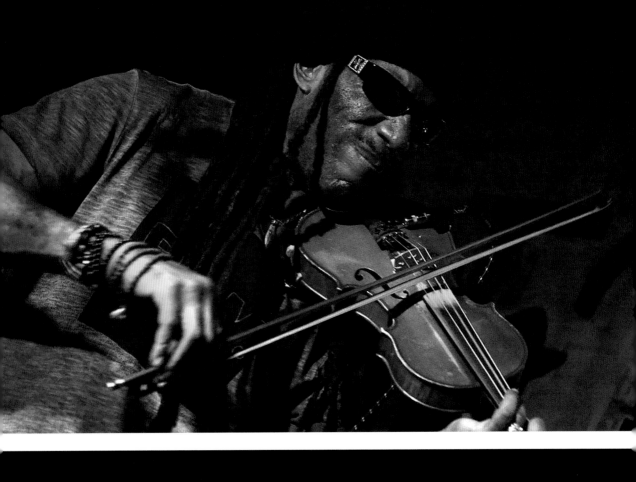
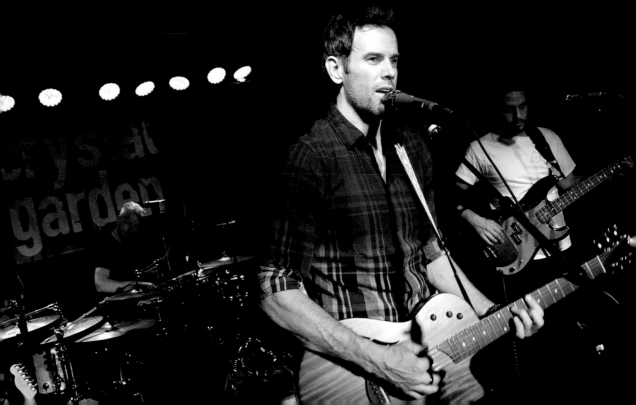

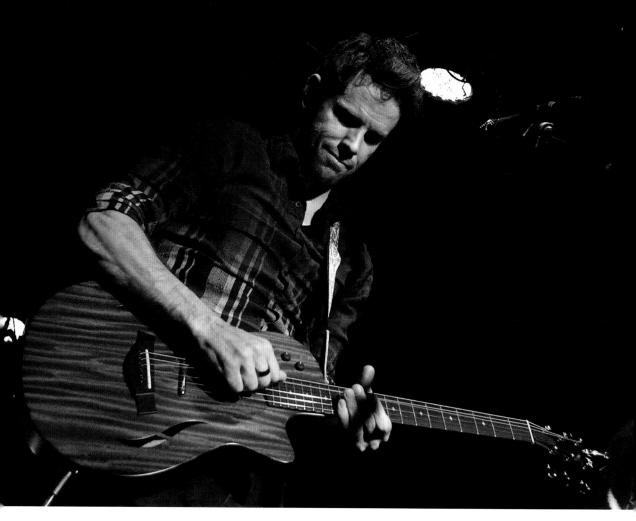

CRYSTAL GARDEN

Fulton 55 in Fresno, CA | June 23, 2016

FACING PAGE, TOP—Boyd Tinsley, violinist for Dave Matthews Band, put this band together to play rock, soul, and funk. *(Nikon D3200, f/4.2, 1/60 second, 82mm, ISO3200)*

FACING PAGE, BOTTOM—This band works together and lives together. You can see that sense of unity in the photo. *(Nikon D3200, f/3.8, 1/80 second, 22mm, ISO3200)*

ABOVE—Most of the time, the singer or bandleader gets the best lighting. That's not because they're more famous or better looking (or at least that's not always the reason!). Generally, it's a result of their central placement on the stage—in a spot that makes for a good photo. *(Mycle Wastman, guitar/vocals. Nikon D3200, f/5, 1/100 second, 34mm, ISO3200)*

"Most of the time, the singer or bandleader gets the best lighting."

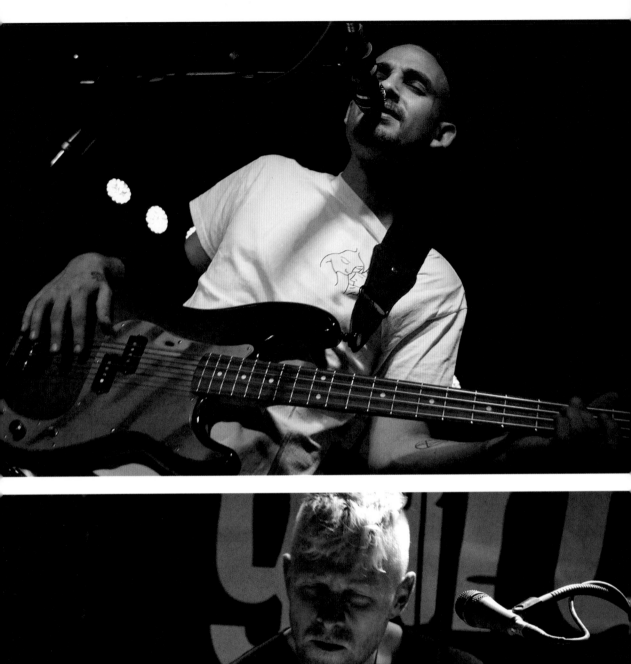
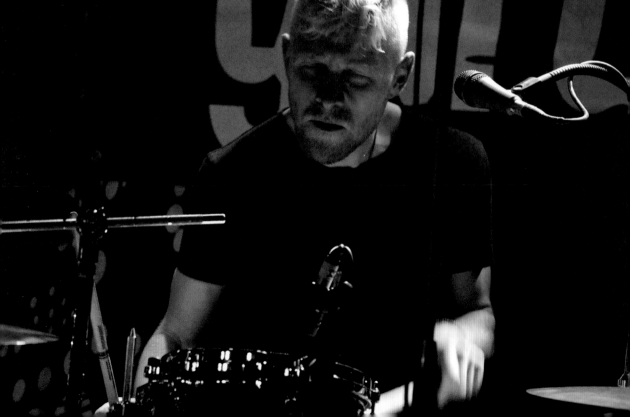

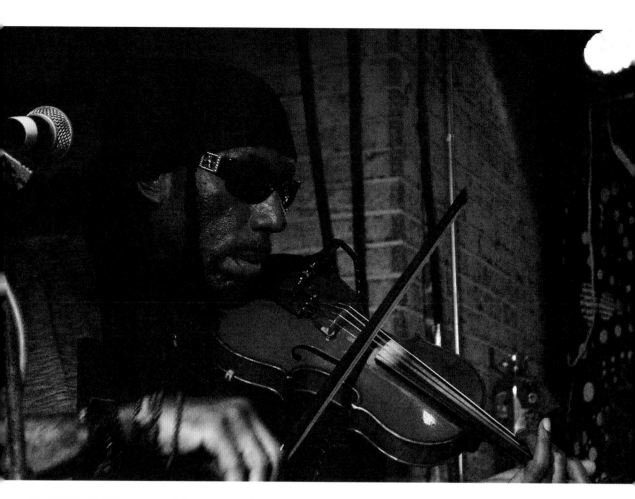

FACING PAGE, TOP—It's a privilege to experience these performances the way I have. But don't exploit that. I let the musicians have their space—because the stage is *their* space. Don't invade the area; accentuate it with your images. *(Charlie Csontos, bassist/backing vocalist. Nikon D3200, f/4.5, 1/80 second, 30mm, ISO3200)*

FACING PAGE, BOTTOM—I e-mailed these photos to the musician. The praise and thanks from the people in my images is one reason why I keep doing this. *(Matt Frewen, drummer. Nikon D3200, f/4.5, 1/60 second, 105mm, ISO3200)*

ABOVE—Boyd Tinsley did a phenomenal job putting this group together and his influence is shown in the music. *(Boyd Tinsley, violin. Nikon D3200, f/5, 1/100 second, 35mm, ISO3200)*

"I let the musicians have their space—because the stage is *their* space. Don't invade the area; accentuate it with your images."

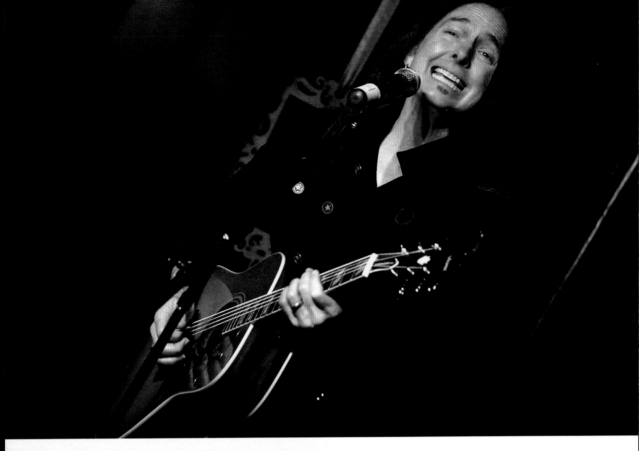

DAMON JOHNSON

Tower Theatre Lounge in Fresno, CA | February 15, 2019

ABOVE—Tower Theatre Lounge, Fresno. Damon Johnson was the singer/songwriter of the 1990s alternative band, Brother Cane. Now he performs as a solo artist. *(Nikon D3200, f/4.2, 1/125 second, 82mm, ISO3200)*

LEFT—During the height of Brother Cane's success, their music was featured in the horror film, *Halloween: The Curse of Michael Myers. (Nikon D3200, f/5, 1/125 second, 135mm, ISO3200)*

BELOW—Damon Johnson has also played with Alice Cooper and Thin Lizzy, and his songs have been recorded by Steven Tyler, Carlos Santana, and Stevie Nicks. *(Nikon D3200, ƒ/4.5, 1/125 second, 102mm, ISO3200)*

RIGHT—It was an honor to meet this musician. He is a classy guy and very passionate about his music. *(Nikon D3200, ƒ/4.5, 1/125 second, 90mm, ISO3200)*

"His songs have been recorded by Steven Tyler, Carlos Santana, and Stevie Nicks."

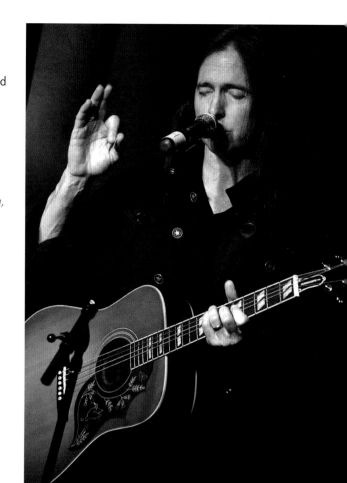

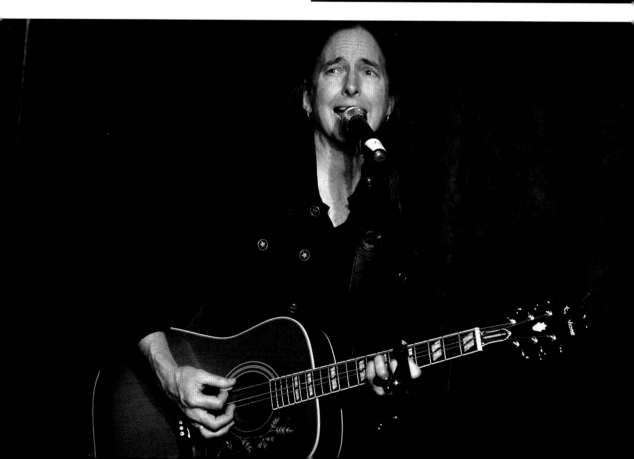

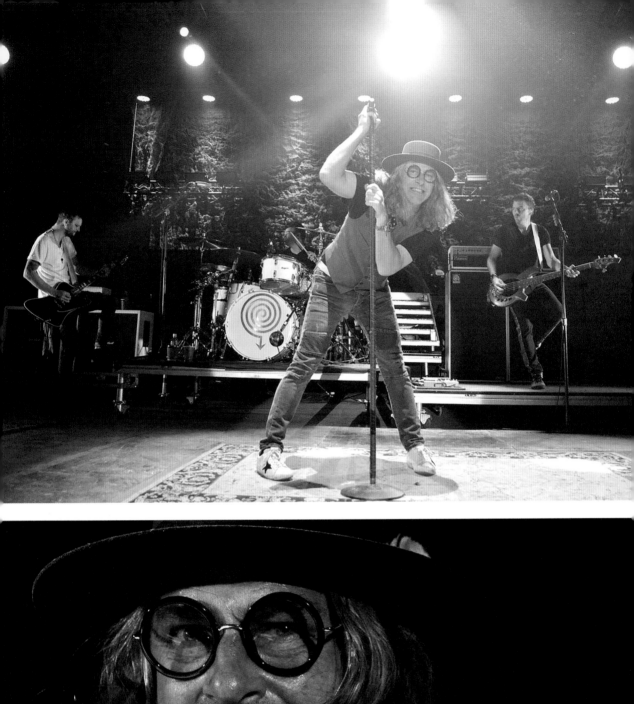
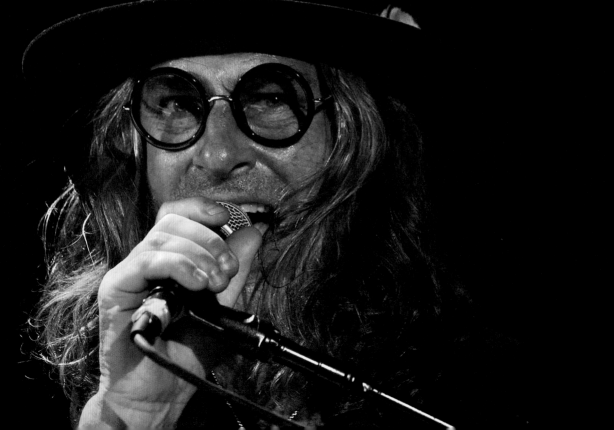

COLLECTIVE SOUL

Tachi Palace in Lemoor, CA | September 6, 2018

FACING PAGE, TOP—A concert is experienced from two different views: the crowd looking at the band, and the band looking out at the crowd. When a member of the band spots you and smiles, it's a rewarding feeling that momentarily closes the gap and makes you feel special. *(Ed Roland, lead vocals. Nikon D3200, f/3.5, 1/200 second, 18mm, ISO 1600)*

FACING PAGE, BOTTOM—Ed Roland, who started out as not only a musician but as a producer, mixer, and engineer, was on the verge of quitting the music industry. Then, he got some musicians together to record a demo in his basement—a demo he hoped would reveal his talents and get his material sold to artists in the industry. Instead, the single "Shine" became instantly popular on local and college radio and they received a label deal from Atlantic! The label insisted on keeping the demo exactly as-is and used it on their debut album, *Hints Allegations and Things Left Unsaid*. As they say, "The rest is history." *(Ed Roland, lead vocals. Nikon D3200, f/4.5, 1/400 second, 110mm, ISO 1600)*

BELOW—Ed's brother, Dean, is the rhythm guitarist. Disputes between sibling bandmates are notorious in the music business, so it's refreshing to see brothers who have stuck it out for many years and are still going strong. *(Dean Roland, rhythm guitar. Nikon D3200, f/4, 1/400 second, 55mm, ISO 1600)*

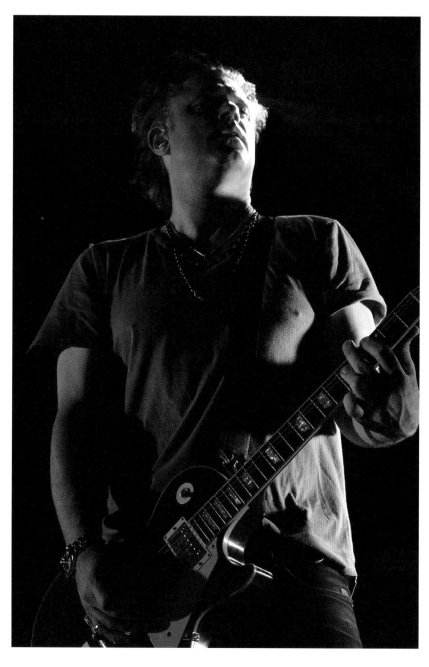

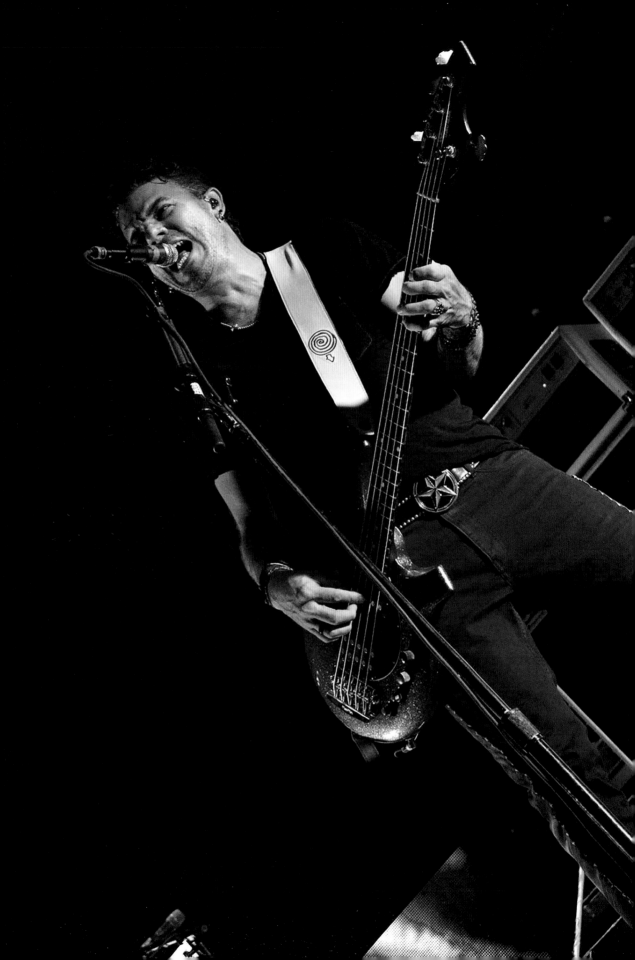

FACING PAGE—The production and stage crew doesn't care what looks good on camera. All they (and the artists) care about is the effect of how they look on stage from the perspective of the audience. They are setting the mood to suit the feel of the song or their image as band or artist. As a photographer, you have to go into it knowing that you won't get the best lighting. It's imperative to rely on your eye and hands to make the most of it. *(Will Turpin, rhythm guitar. Nikon D3200, f/4, 1/400 second, 55mm, ISO 1600)*

RIGHT—I mostly shoot with my camera in manual exposure mode and set to continuous shooting, so I can press and hold the shutter release button to take multiple photos in rapid succession. I don't want to miss any moment—it could be the money shot! *(Jesse Triplett, lead guitar. Nikon D3200, f/4.5, 1/200 second, 30mm, ISO 1600)*

BELOW—Heaven let your light shine down. I've always liked this band, but seeing them live made me an even bigger fan. *(Ed Roland, lead vocalist. Nikon D3200, f/3.5, 1/250 second, 18mm, ISO 1600)*

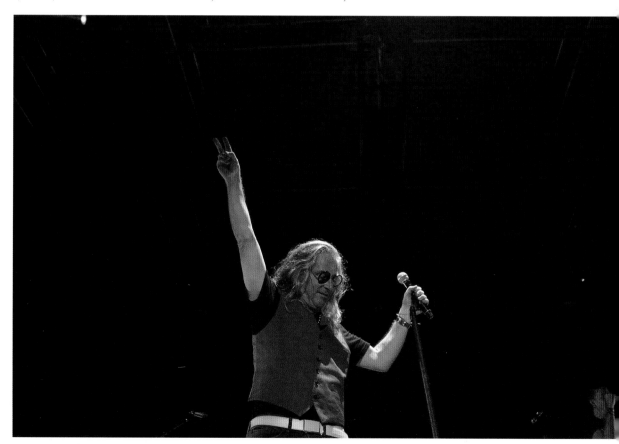

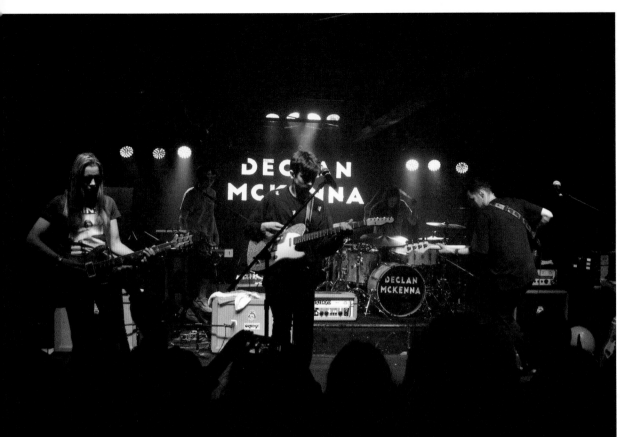
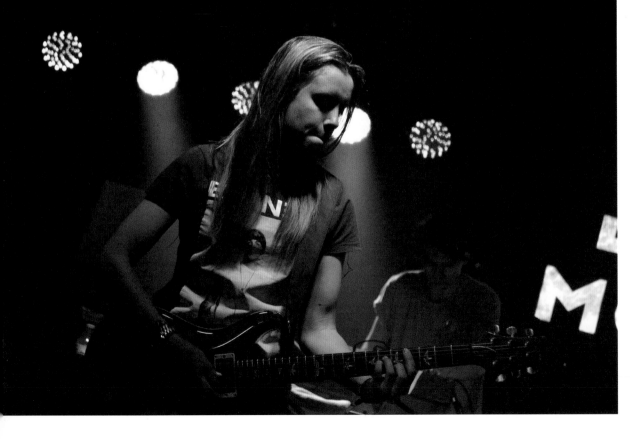

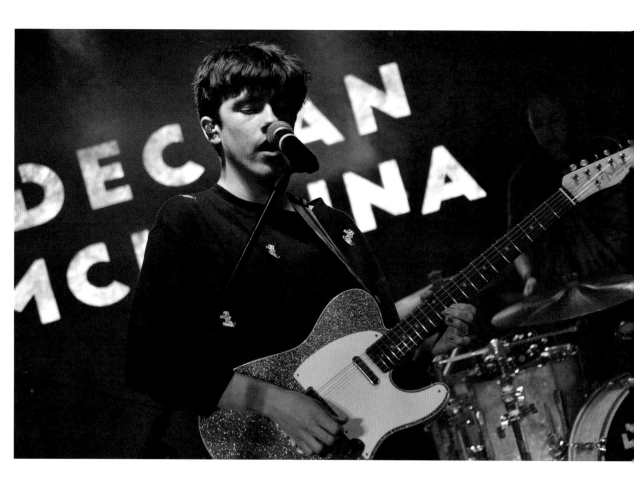

DECLAN McKENNA

Strummer's in Fresno, CA | April 19, 2018

FACING PAGE, TOP—The concept of "mise en scene" means using the setting, the subject, and everything else in your frame to tell the story. Explore the whole stage and the setup through your lens and try to evoke something more than what's being shown. *(Declan McKenna and his band. Nikon D3200, ƒ/3.5, 1/100 second, 18mm, ISO3200)*

FACING PAGE, BOTTOM—Declan McKenna's name might be on the albums and posters, but artists like him are nothing without their bands. As great as he is as a young artist, he had one great band to support him—and they deserve some recognition as well. *(Isabel Torres, guitar. Nikon D3200, ƒ/4.2, 1/100 second, 65mm, ISO1600)*

ABOVE—Going to shows like this allows you to open up your tastes to all the music genres out there. Sometimes when I go to a show, I know who the musicians are; sometimes I don't. But even when I don't know the band beforehand, I usually become a fan by the time the concert is over. *(Nikon D3200, ƒ/4.2, 1/100 second, 72mm, ISO1600)*

"Explore the whole stage and the setup through your lens and try to evoke something . . ."

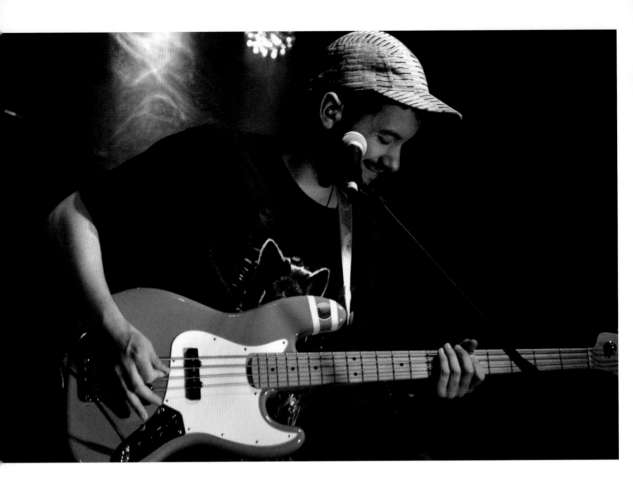

ABOVE—Smiling while playing—that's always a good combination. *(Nikon D3200, f/5.3, 1/100 second, 160mm, ISO 1600)*

FACING PAGE, TOP—A close-up portrait—in color or in black & white—always works. In this case, his persona and attire was colorful, so I decided that the best way to take his photo was in color. *(Nikon D3200, f/5.3, 1/100 second, 160mm, ISO 1600)*

FACING PAGE, BOTTOM—Declan McKenna has received a lot of praise in the entertainment industry. Adele has complimented his talents and efforts, especially how he's making things happen at his young age. During McKenna's first appearance on the talk show, Conan O'Brien announced that, "This guy is going to rule the world." With his youthful exuberance, outspoken lyrics, and international appeal, he has the potential to do just that. *(Nikon D3200, f/4, 1/100 second, 55mm, ISO 1600)*

"His persona and attire was colorful, so I decided that the best way to take his photo was in color."

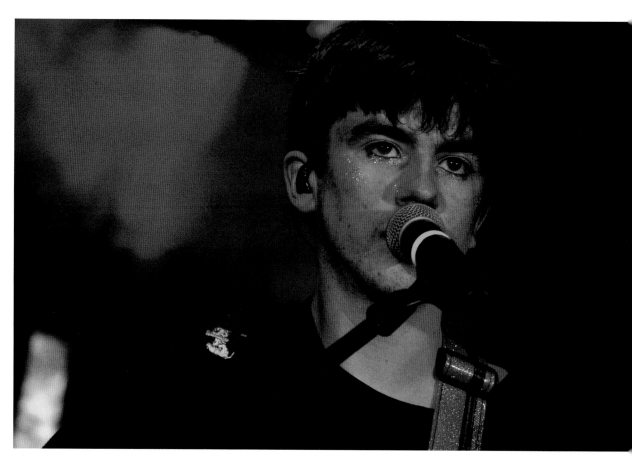
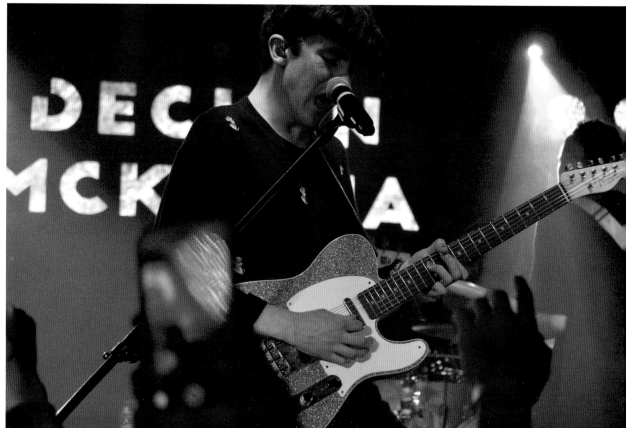

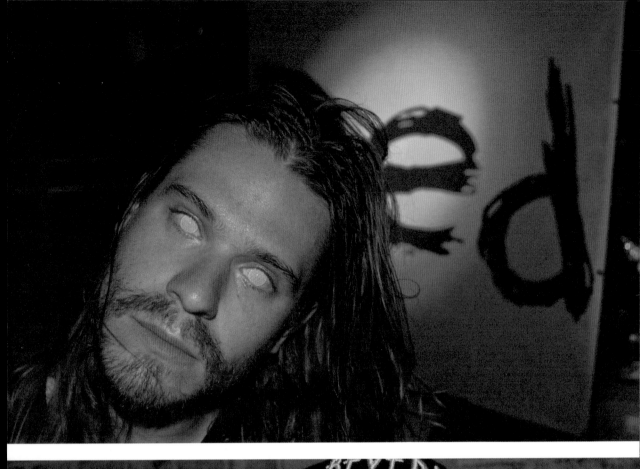

DED

Fulton 55 in Fresno, CA |
June 16, 2017

FACING PAGE, TOP—Horror sells—and
this band had no shortage of that.
(Kyle Koelsch, bass. Nikon D3200,
f/4, 1/30 second, 24mm, ISO800)

FACING PAGE, BOTTOM—Besides the
contact lenses, their show was a head
banging good time. *(Joe Cotela, lead*
vocals. Nikon D3200, f/4.2, 1/30
second, 26mm, ISO800)

RIGHT—The power of someone's pres-
ence is revealed in their eyes—even if you can't see
them. *(David Ludlow, guitar. Nikon D3200, f/4.2,*
1/30 second, 26mm, ISO800)

BELOW—To play live with those things in your eyes
for hours, banging your head around? It must take
a lot of patience. *(Matt Reinhard, drums. Nikon*
D3200, f/4.2, 1/30 second, 26mm, ISO800)

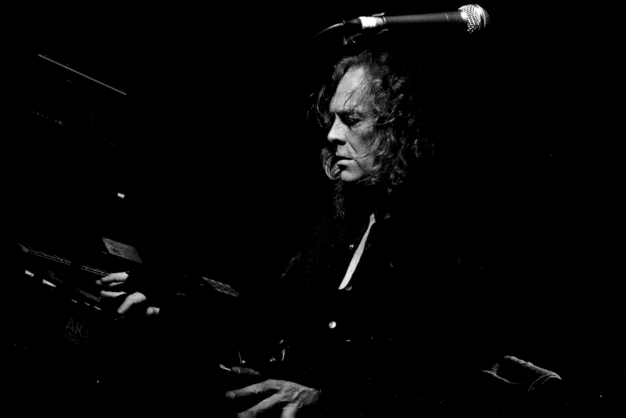

"The life of Tim 'Ripper' Owens inspired the 2001 film *Rock Star*, starring Mark Wahlberg."

DIO'S DISCIPLES

Fulton 55 in Fresno, CA | March 24, 2018

FACING PAGE, TOP—The life of Tim "Ripper" Owens inspired the 2001 film *Rock Star*, starring Mark Wahlberg. He was in a Judas Priest tribute band, got discovered by them, and was asked to join the real band when the original singer, Rob Halford, decided to leave the group. He did, and the rest is history. *(Tim "Ripper" Owens, lead vocals. Nikon D3200, f/4.5, 1/100 second, 55mm, ISO 1600)*

FACING PAGE, BOTTOM—When you think of rock, you may not think of keyboards—but every instrument deserves their moment in the spotlight. *(Scott Warren, keyboardist. Nikon D3200, f/8, 1/100 second, 40mm, ISO 1600)*

ABOVE—Give me your metal face! Give me your metal face! *(Bjorn Englen, bass. Nikon D3200, f/4.5, 1/100 second, 55mm, ISO 1600)*

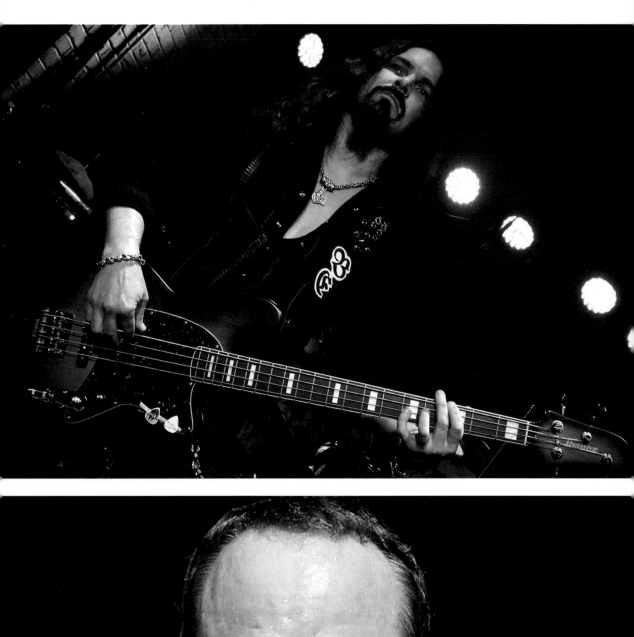
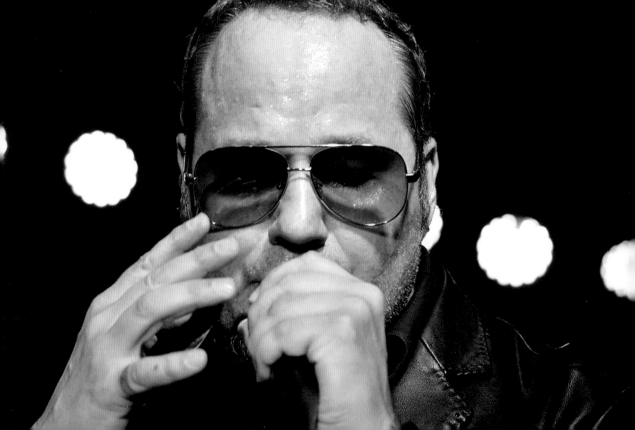

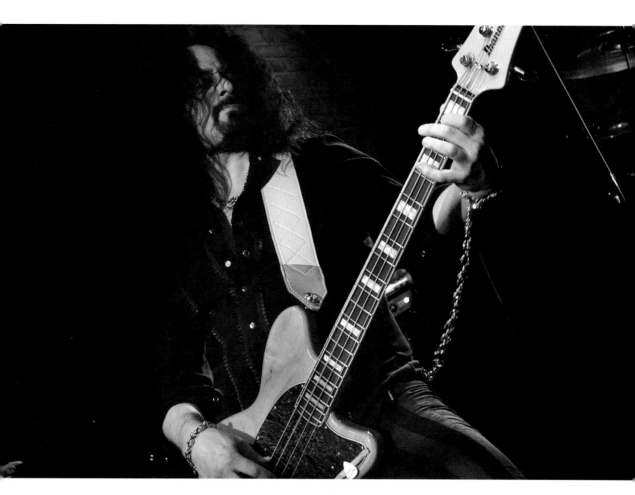

FACING PAGE, TOP—A full-body shot of a musician and his instrument. If you can get both in frame then you have a compelling image. *(Bjorn Englen, bass. Nikon D3200, f/8, 1/100 second, 34mm, ISO1600)*

FACING PAGE, BOTTOM—There's got to be some trust between you and the artist during the photography process. He or she knows you're there but they're not there to impress you, they're trying to impress the crowd. But at some point, they may give you a pose or look at you for you to seize the moment. You can do that or bide your time to wait for the image you want. The musicians may be in control of the show itself, but you're in control of how that show will be perceived. When people see your photographs, it can change people's perspective and you can make people see and remember the show the way how you saw it. *(Tim "Ripper" Owens, lead vocals. Nikon D3200, f/4.5, 1/100 second, 55mm, ISO1600)*

ABOVE—Musicians represent their genre of music through the image they present. As a photographer, your job is to capture that image. With metal, if the performer is wearing black, with a chain, in leather, tattoos, and long hair, you can capture that look and people will automatically know what it is that they do. *(Bjorn Englen, bass. Nikon D3200, f/5.3, 1/100 second, 40mm, ISO1600)*

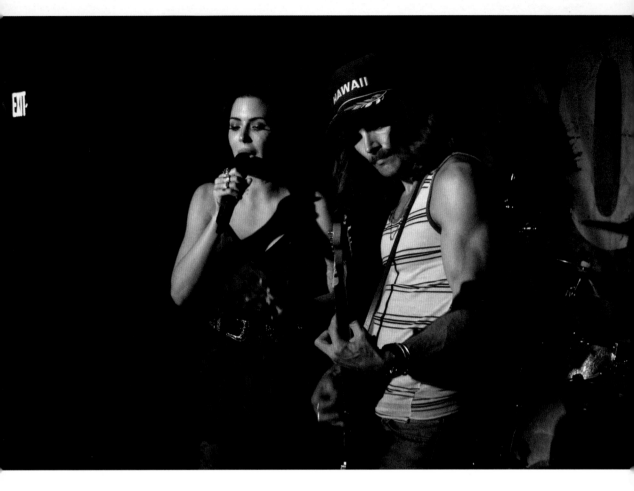

DOROTHY

Fulton 55 in Fresno, CA | July 12, 2018

FACING PAGE—If there was an modern, living Janis Joplin, it would be this young lady. More women in rock is what we need. The genre needs more racial and gender diversity. Hopefully, my photos will inspire young women to want to pursue this music—and sometimes that's all it takes. If I can do that, I'd be really proud of myself. *(Nikon D3200, ƒ/4.2, 1/100 second, 60mm, ISO3200)*

ABOVE—The singer-and-guitarist photo is an iconic image. When pursuing concert photography, I suggest looking for a moment like this to capture. The best have done it, and so should you. *(Eli Wulfmeier, guitar. Nikon D3200, ƒ/4.8, 1/50 second, 32mm, ISO3200)*

"Hopefully, my photos will inspire young women to want to pursue this music."

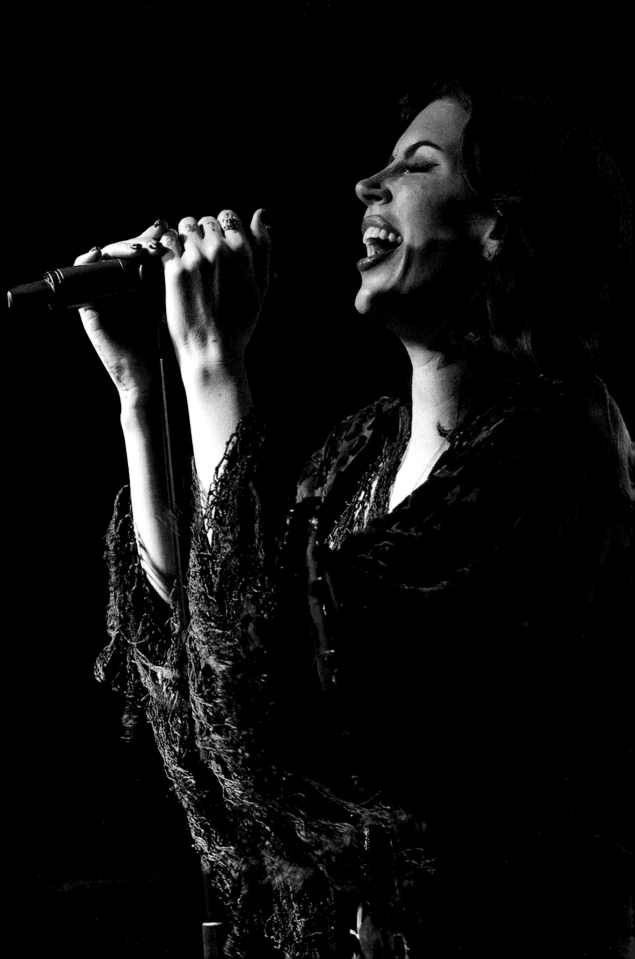

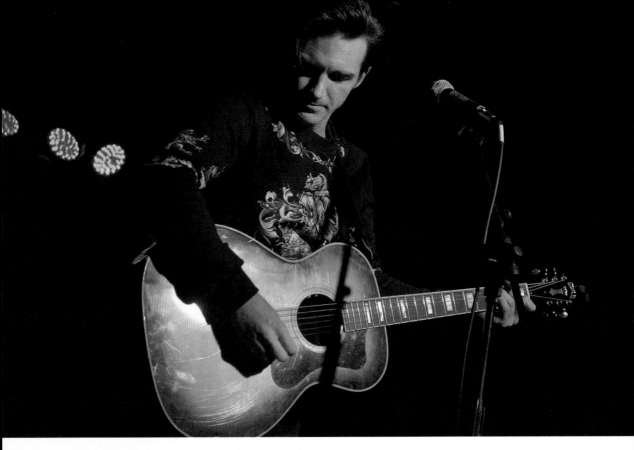

DRAKE BELL

Fulton 55 in Fresno, CA | January 10, 2018

ABOVE—Drake Bell is a former child actor (from Nickelodeon's *Drake and Josh*) and star of the film *College*. On this evening, he performed a solo, acoustic set. There are few people who can juggle the acting and music thing—and fewer still who can do both well. Drake can. *(Nikon D3200, ƒ/5.3, 1/100 second, 46mm, ISO 1600)*

LEFT—Every now and then, I prefer these stripped down performances. Sometimes, the best platform to showcase your musicianship is through an acoustic show. For someone who's primarily known as an actor, this proved that he's a talented musician. *(Nikon D3200, ƒ/5.6, 1/200 second, 55mm, ISO 1600)*

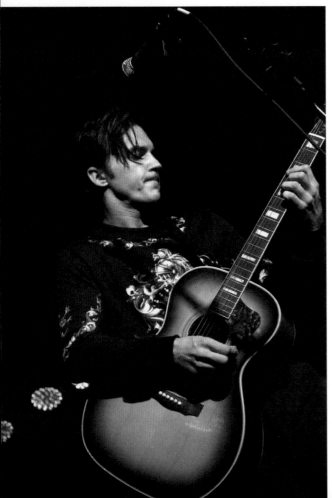

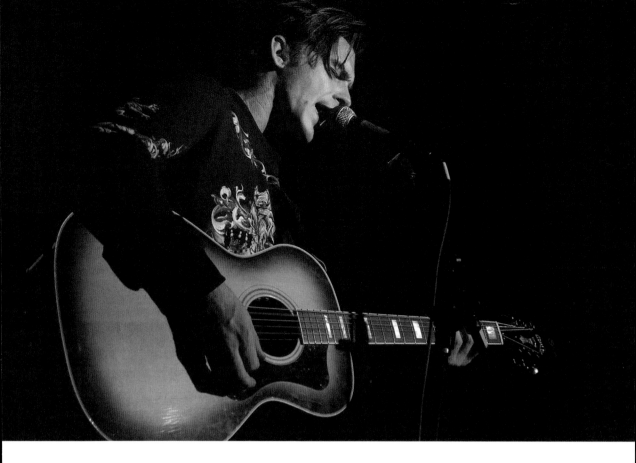

ABOVE—Drake's style is rock and rockabilly, a throwback musical style complemented by his classic greaser haircut and clean-cut attire. We can't travel back in time to capture these styles in our images—but finding musicians with an old-school style can give your images that same nostalgic feel. It can transcend a single point in time. *(Nikon D3200, ƒ/5.3, 1/200 second, 44mm, ISO 1600)*

BELOW—In a close-up portrait, the most expressive attribute is the eyes. *(Nikon D3200, ƒ/5.6, 1/200 second, 190mm, ISO 1600)*

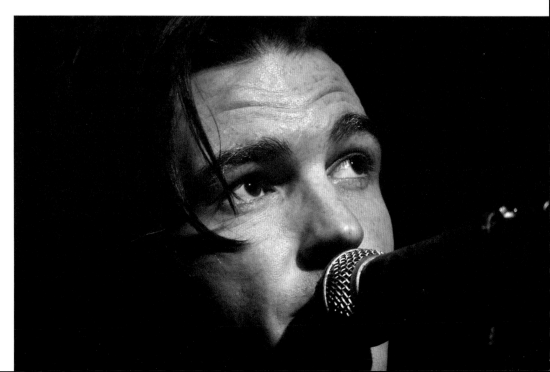

FOXTRAX

Strummer's in Fresno, CA | May 20, 2018

BELOW—After talking with the band for an interview, I photographed them posing outside the venue. This was a little different for me. The nice natural light made it feel like I was capturing an album cover for them. *(Nikon D3200, f/4, 1/30 second, 24mm, ISO3200)*

BOTTOM—The band members said they were compelled to pursue their music dreams once they were done with college. So they hightailed it from their home in New York to a secluded cabin in the woods of North Carolina. There, they thought up the name of their band, which derives from the tracks left in the snow by the foxes that became an allegory for their future. *(Ben Schneid, guitar/keyboard/organ/vocals. Nikon D3200, f/5, 1/200 second, 38mm, ISO1600)*

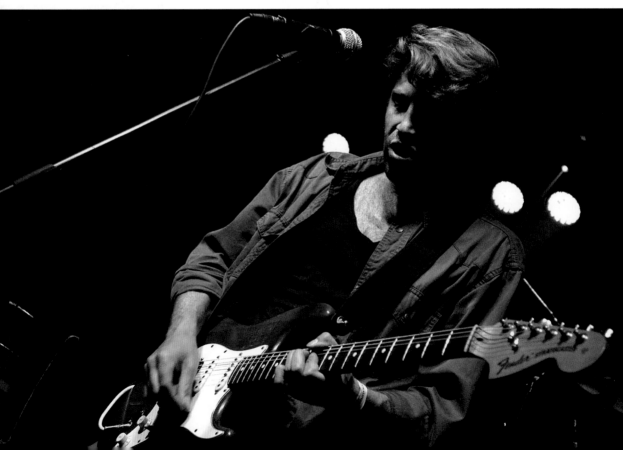

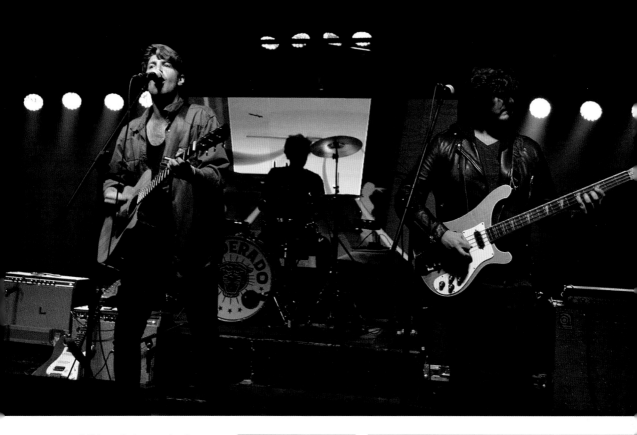

ABOVE—A full band shot is the best kind of group photography out there. The group photo captures the individuality of each person. A regular group picture often has everybody smiling directly at the camera, they represent one emotion but there's no uniqueness to it. In a group performance image, they're all making different faces, playing different instruments, at different parts of the stage, it's a symphony of various movements and emotions. *(Nikon D3200, f/4.2, 1/125 second, 26mm, ISO 1600)*

RIGHT—"People in our generation, the millennials, we see that there's not too much nice stuff going on in the world right now. Music has always been a reflection on the times and a beacon of hope and artists are making inspirational music because people are feeling a little off from what's going on in the world," said Foxtrax member Jared Stenz. *(Jared Stenz, bass. Nikon D3200, f/4.5, 1/200 second, 28mm, ISO 1600)*

ABOVE—"I want them to find that same self-discovery within themselves. Music is our thing, but no matter what you decide to do everyone has got their own path. To me, I thought the best music growing up was the kind that made me contemplate life. I hope our music is doing that for other people," says Ben Schneid. *(Ben Schneid, guitar/keyboard/organ/vocals. Nikon D3200, ƒ/4.8, 1/200 second, 116mm, ISO 1600)*

FACING PAGE—"I hope when you're happy we can lift you to a new high and when you're feeling sad we can be that comforting feeling in your life, and that we can touch people in a meaningful way," says Jared Stenz. *(Jared Stenz, bass. Nikon D3200, ƒ/4.8, 1/100 second, 32mm, ISO 1600)*

"Music is our thing, but no matter what you decide to do everyone has got their own path."

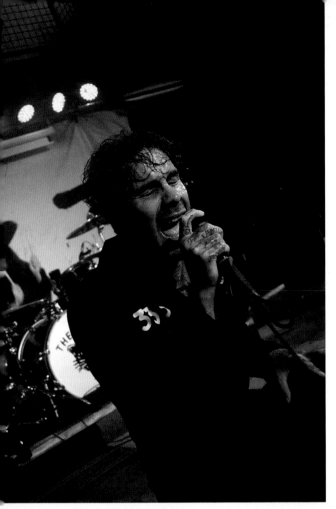

THE FEVER 333
Fulton 55 in Fresno, CA | June 1, 2018

LEFT—The performers don't concern themselves with staying put during their set. That makes it hard to get a good photo of them. My advice: make sure to get them where you know for sure (or instinctively) they'll be still for a moment. It may be the singer hitting a high note or belting out the chorus, or the guitar player doing a solo. *(Jason Aalon Butler, lead vocals. Nikon D3200, f/4.5, 1/125 second, 28mm, ISO3200)*

BELOW—If you can photograph a band that is woke and aware, with music that goes beyond the confines of just sound and lyrics—then you've captured something with a deeper substance. Whether the artists are political, humanitarian, or outspoken, (however you want to describe it) a message elevates the work beyond just concert photography. *(Stevis Harrison, guitar. Nikon D3200, f/4.2, 1/100 second, 26mm, ISO3200)*

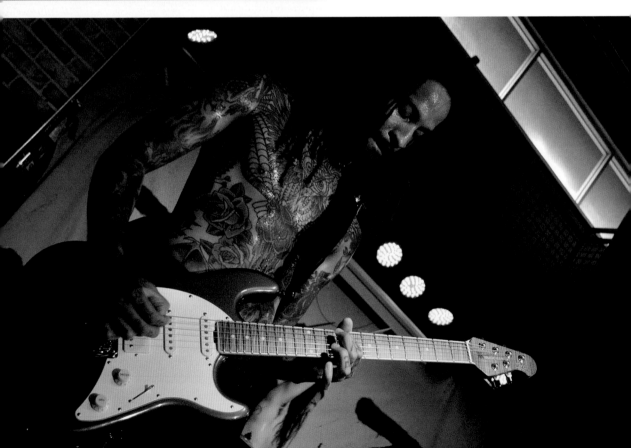

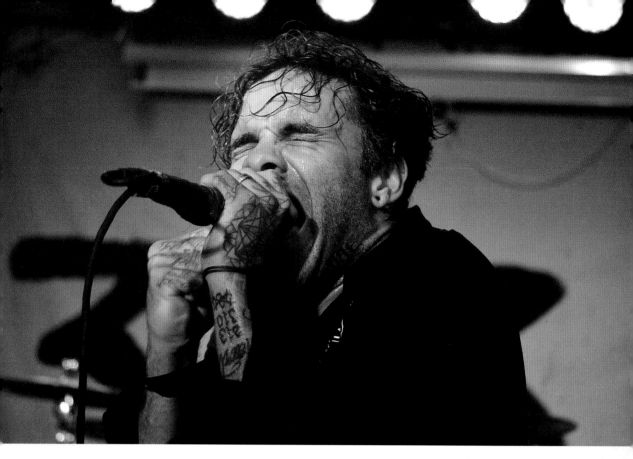

ABOVE—There is a saying in football: you take what the offense (or defense) gives you. Likewise, I believe that you should take the photographs you want. The musician may dictate the pose, but you dictate the composition and setup of the shot. You make them look the way you want them to look. The angle, color scheme—it's up to you to decide. They are your muse. *(Jason Aalon Butler, lead vocals. Nikon D3200, f/4.2, 1/100 second, 55mm, ISO3200)*

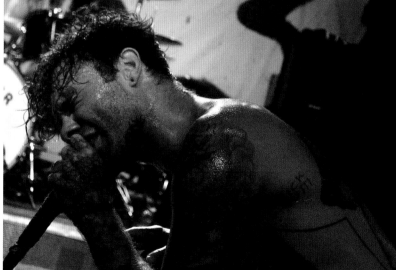

RIGHT—Extreme showmanship can make it hard to get shots, but I like it because it gives you the chance to be enraptured by the show. This guy climbed up the rafters and was singing above the crowd. It was like watching Eddie Vedder! Don't stress out if you can't get the shot. It's okay to keep some memories for yourself. If you were there, you know—and that's the main thing: you were there. *(Jason Aalon Butler, lead vocals. Nikon D3200, f/5.3, 1/100 second, 46mm, ISO3200)*

GEOFF TATE (FORMER LEAD SINGER OF QUEENSRYCHE)

Strummers in Fresno, CA | February 3, 2016

LEFT—Sometimes the time comes for you to take a photo—and you don't have your camera. Every now and then, a cell phone camera will get the job done. It may not have the quality you want, but it's better to capture the moment as best you can than to live with the regret of not having captured it at all. *(Apple iPhone 4, f/2.8, 1/17 second, 3.85mm, ISO1000)*

FROM ASHES TO NEW

Save Mart Center in Fresno, CA | November 12, 2018

FACING PAGE, TOP—I got to interview Danny Case backstage before the show. "I think that over the years the nu-metal genre has been overlooked," he said. "And some of the biggest bands playing the biggest stages in the world are nu-metal bands like Disturbed and Korn—and there's a lot of longevity in that style of music. I think people want more

of it." *(Danny Case, lead vocals. NIKON D3200, f/4.5, 1/160 second, 30mm, ISO1600)*

FACING PAGE, BOTTOM—And the message Danny had for the Fresno attendees before the show... "There's always going to be bad times in life, and bad things happen, it doesn't mean that it has to define you. Let the bad times make you stronger, not tear you down." *(Danny Case, lead vocals. NIKON D3200, f/4, 1/160 second, 55mm, ISO1600)*

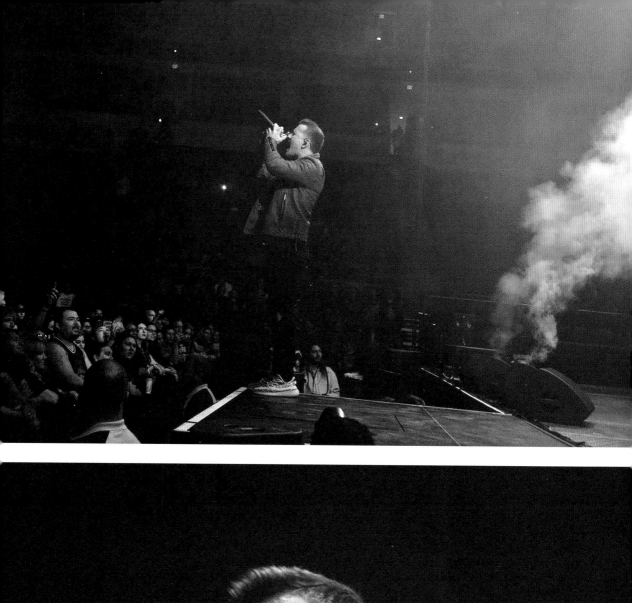
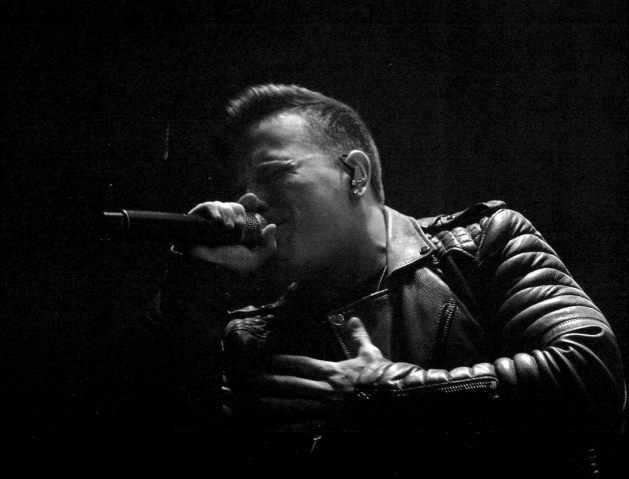

GHOST

Rainbow Ballroom in Fresno, CA | June 30, 2017

BELOW—It's rewarding when you can photograph a band or artist that is highly theatrical. A stage production like this—with makeup, pyrotechnics, costumes, props, etc.—is almost like having a film set right before your eyes. Best of all, you get to enjoy and photograph it without the big budget coming out of your pocket! Theatricality and imagination always breathes life into a photo. *(NIKON D3200, f/3.5, 1/100 second, 18mm, ISO 1600)*

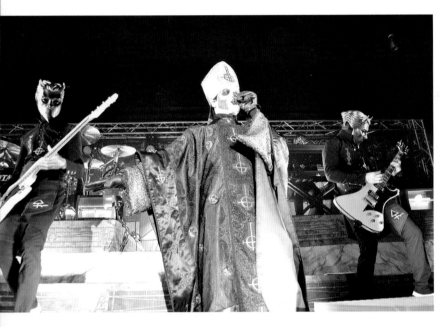

BOTTOM—"A Nameless Ghoul." That's what the instrumentalists are called. The identity of the guitarist, along with other members of the band, remains a mystery; no one knows who they are or what they look like. *(Nameless Ghoul, guitar. NIKON D3200, f/3.5, 1/100 second, 18mm, ISO 3200)*

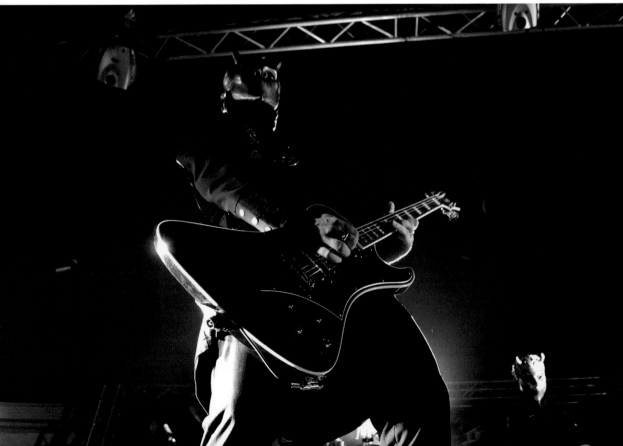

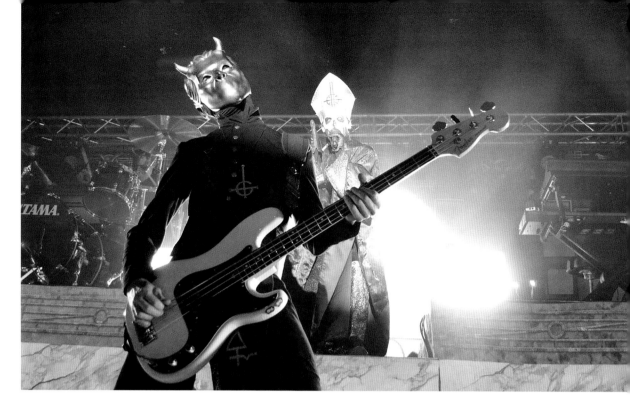

ABOVE—Use your camera position to configure the subjects as you wish. Here, one member is shown over the shoulder of another. I could have changed my position to show them side by side—or in whatever placement I wanted. *(Nameless Ghoul, bass. NIKON D3200, f/4.2, 1/100 second, 26mm, ISO3200)*

BELOW—One moment the performance can be upbeat and sexy, the next it can be dark and scary. Usually, the performance represents the very thing the band is trying to convey. Embrace everything in your shots; each aspect is equal in presentation. *(Papa Emeritus III, lead vocals. NIKON D3200, f/4.5, 1/100 second, 30mm, ISO3200)*

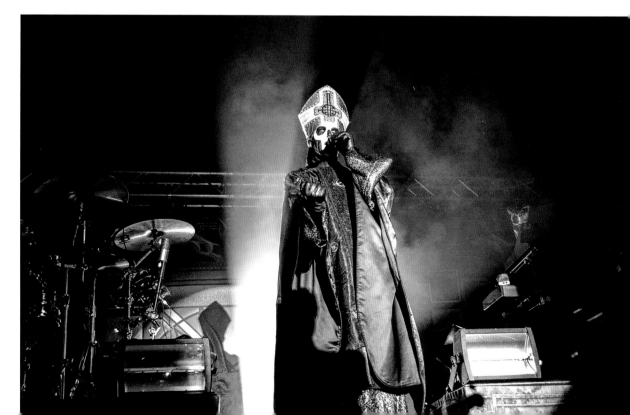

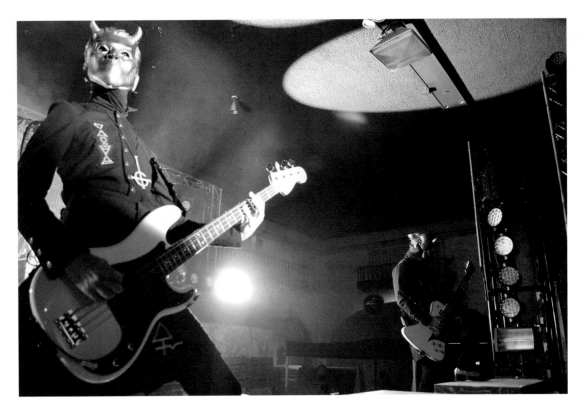

ABOVE—Here you have one instrumentalist in the foreground (the part of a view that is nearest to the observer) and the other in the middle ground (the middle distance of an image). This gives you a variety; you can choose which one you want to look at. *(NIKON D3200, f/3.5, 1/100 second, 18mm, ISO 1600)*

BELOW—The singer has been through four iterations of his name. His identity hadn't been revealed until recently; he is Tobias Forge. *(Papa Emeritus III, lead vocals. NIKON D3200, f/5.3, 1/100 second, 44mm, ISO 1600)*

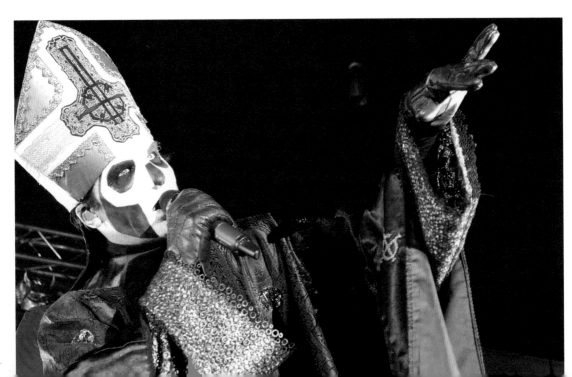

THE WHITE BUFFALO

Strummer's in Fresno, CA | August 4, 2018

ABOVE—This band's most established originals and covers have been featured in popular television shows like *Sons of Anarchy*. *(Jake Smith, singer/song-writer/guitarist. NIKON D3200, ƒ/4.8, 1/250 second, 32mm, ISO1600)*

RIGHT—Study film angles so your photos can evoke a feeling. Close up, medi-um shot, long shot, Dutch angle, high angle, low angle, two shot, eye level, the list goes on. Those shots are the ones that are the

most compelling. *(Tommy Andrews, bass. NIKON D3200, ƒ/4.5, 1/125 second, 30mm, ISO1600)*

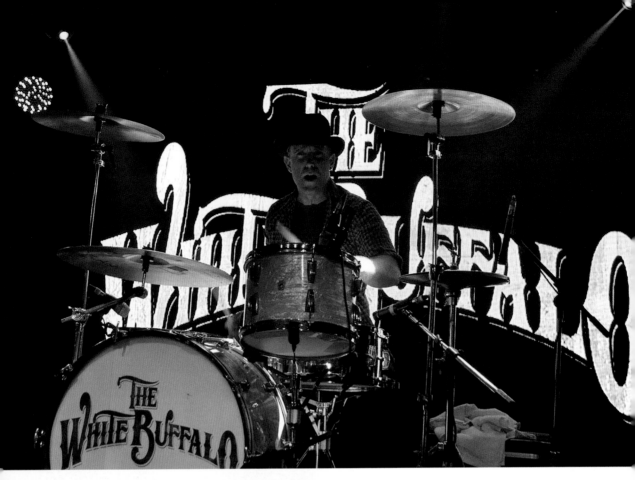

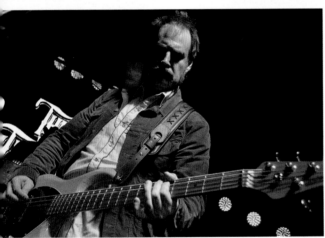

ABOVE—Product placement, in this case logo placement can add character to your photo. It gives the performers a credit—and if someone doesn't know who the band is? Well, now they know. *(Matt Lynott, drummer. NIKON D3200, f/5, 1/125 second, 35mm, ISO1600)*

LEFT—Discover your style in the process. Separate yourself from your peers and other photographers you may admire. Learn—but then find yourself. When people see your portfolio, do they immediately recognize that the images are by you? Speak your voice through the power of the image. *(Tommy Andrews, bassist. NIKON D3200, f/4.2, 1/160 second, 26mm, ISO1600)*

"When people see your portfolio, do they immediately recognize that the images are by you?"

TOP RIGHT—It's tough to do close-up portraits of the singer when they are moving and the lights are changing—but when you do, you have a great shot that defines them as an artist and perhaps as a person. *(Jake Smith, singer/ songwriter/guitar- ist. NIKON D3200, f/5.3, 1/200 second, 160mm, ISO 1600)*

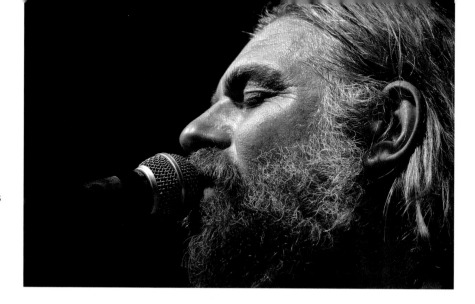

BOTTOM RIGHT—Prac- tice makes perfect. Be on alert for bands that are coming to your town. With the Inter- net, there are many re- sources to see what's going on in your community. Your local venues have social media and main web- sites, so check their events calendars and see if there are any upcoming shows. The more shows you go to, the better you'll be at your craft. *(Jake Smith, singer/songwriter/gui- tarist. NIKON D3200, f/4.8, 1/160 second, 125mm, ISO 1600)*

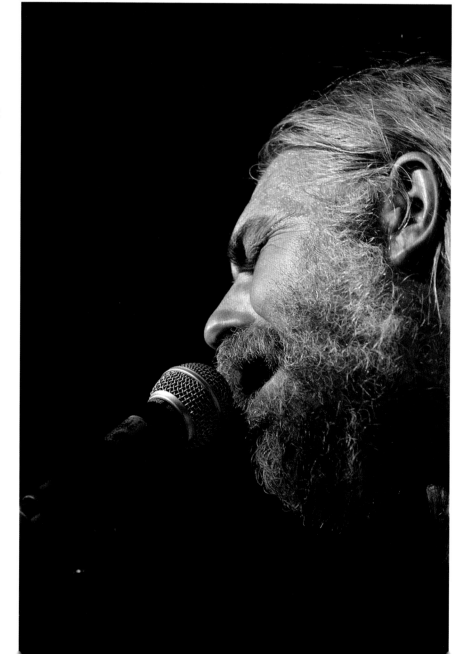

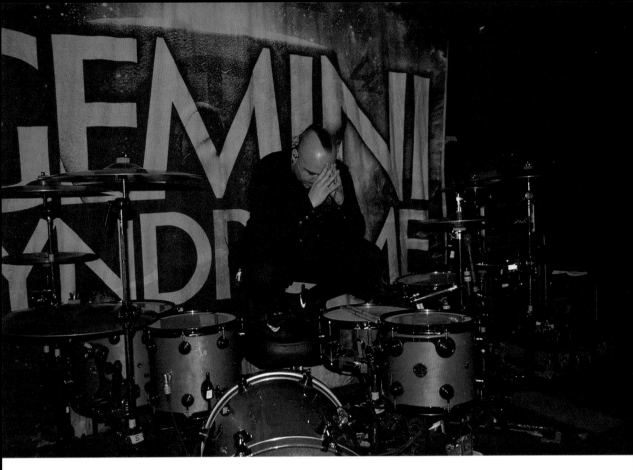

GEMINI SYNDROME

Fulton 55 in Fresno, CA | January 29, 2017

ABOVE—Saying a prayer. I live for moments like this, when performers show their human and spiritual side. Sometimes the music isn't always the most interesting part of the photo. *(Brian Steele Medina, drummer. NIKON D3200, ƒ/3.5, 1/60 second, 18mm, ISO800)*

"It's not a conventional concert venue, but this band turned it into their own little rock joint."

HOLY WHITE HOUNDS

Crawdaddy's in Visalia, CA | October 20, 2016

FACING PAGE, TOP—This place is more of a bar and restaurant that provides music to local patrons. It's not a conventional concert venue, but this band turned it into their own little rock joint. *(NIKON D3200, ƒ/6.3, 1/60 second, 35mm, ISO800)*

FACING PAGE, BOTTOM—It's refreshing to see bands who don't take themselves too seriously. There's a sense of fun to them. These guys were cracking jokes and making funny faces while playing. You could tell that they weren't in it for the money and fame but for the pure joy of playing music. *(NIKON D3200, ƒ/5.3, 1/60 second, 40mm, ISO800)*

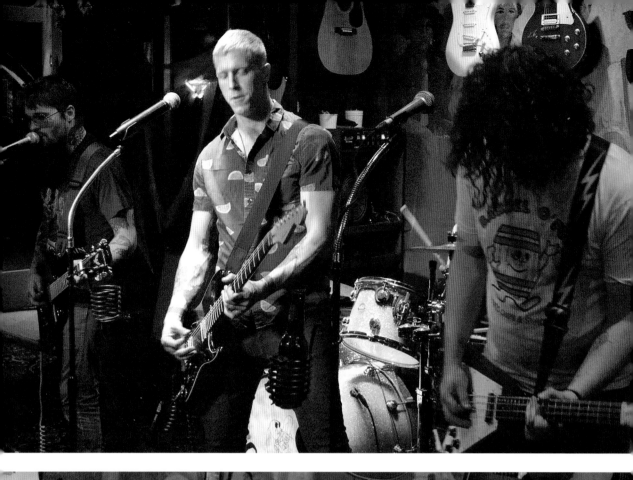
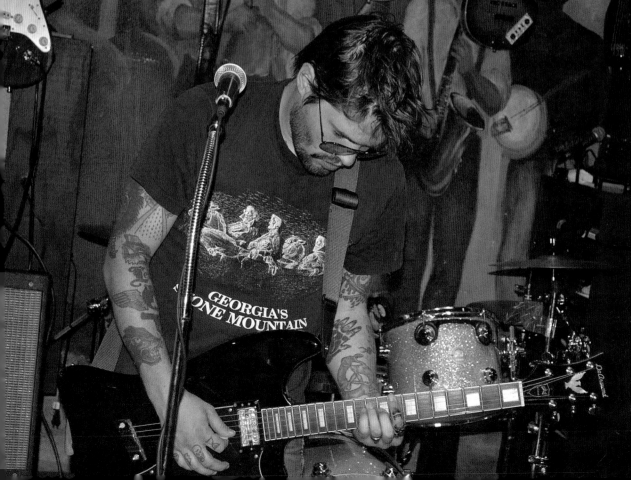

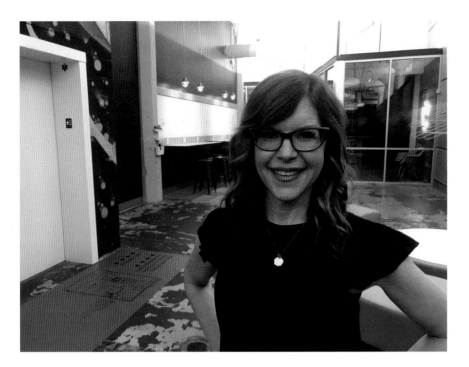

LISA LOEB

South Bitwise Stadium in Fresno, CA |
July 21, 2018

ABOVE—Lisa Loeb's most famous single, "Stay (I Missed You)" appeared on the soundtrack for the '90s film *Reality Bites.* She was neighbors with Ethan Hawke, the leading man of the film, when they both lived in New York—and they were friends amongst the community of artists they socialized with. Hawke liked her song and sent it to the director, Ben Stiller, for consideration. Stiller liked it too, and it became the signature song of the film. It also became a number one hit, making Loeb the first artist to have the top spot on the charts without being signed to a major label. Today, she's married and is a mother, an actress, author, and philanthropist. *(Apple iPhone 7, f/1.8, 1/15 second, 4mm [28mm equivalent on 35mm format], ISO80)*

LIT

Full Circle Brewing Company in Fresno, CA |
September 8, 2018

FACING PAGE, TOP—Jeremy is the brother of singer A. Jay. The boys from Fullerton, CA, burst onto the scene with their seminal track, "My Own Worst Enemy," which won the 1999 Billboard Music award for Best Modern Rock Track. *(Jeremy Popoff, lead guitar. NIKON D3200, f/3.5, 1/250 second, 18mm, ISO1600)*

FACING PAGE, BOTTOM—Yes, I'm about to use their band name as a pun, but their show was "lit." *(Jay Popoff, vocals. NIKON D3200, f/5, 1/200 second, 135mm, ISO1600)*

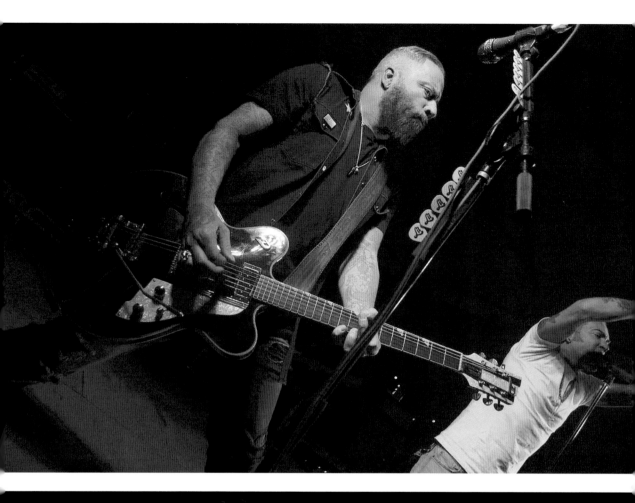

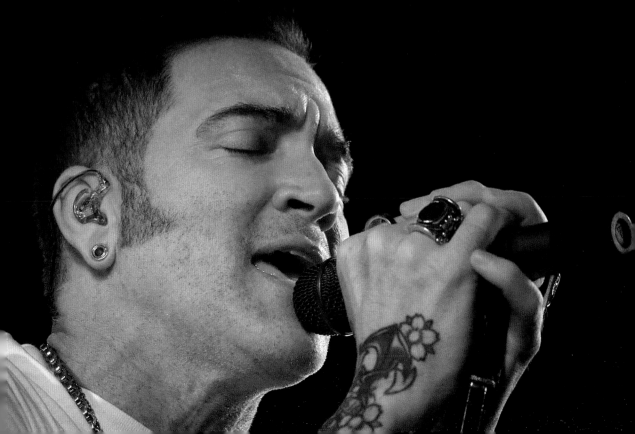

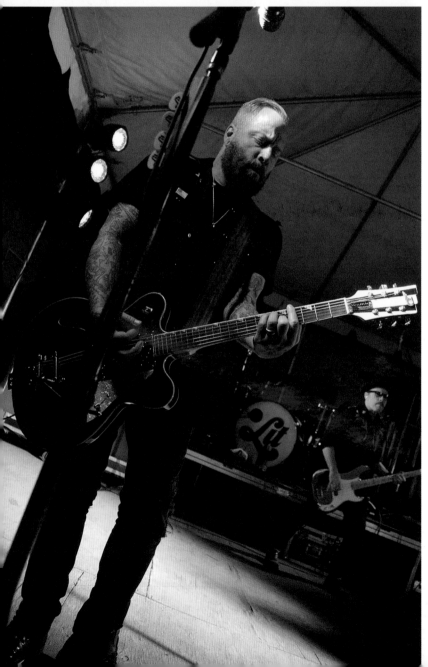

TOP LEFT—For their song "Miserable," the band Lit is remembered for their stylish music video where a miniature version of the band played on the body of a huge version of *Baywatch* star Pamela Anderson. *(Kevin Baldes, bass, vocals. NIKON D3200, ƒ/3.5, 1/200 second, 18mm, ISO 1600)*

BOTTOM LEFT—Rock photography is a lot like nature photography, because you're recording these subjects in their natural habitat: the stage. Performers are a unique species, and whether they're singing or playing an instrument, they're in their element. Be as respectful with the camera as if you were photographing a wild animal. Make the viewer feel that you're taking them right into that subject's environment. *(Jeremy Popoff, lead guitar. NIKON D3200, ƒ/3.5, 1/200 second, 18mm, ISO 1600)*

FACING PAGE—What's cool about photographing bands with some history behind them is you get to see their evolution. Lit is known for alternative rock, but recently they have begun to add country to their sound. You can hear and see their maturity in their music and presentation. *(Ryan Gillmor, guitar. NIKON D3200, ƒ/4, 1/200 second, 22mm, ISO 1600)*

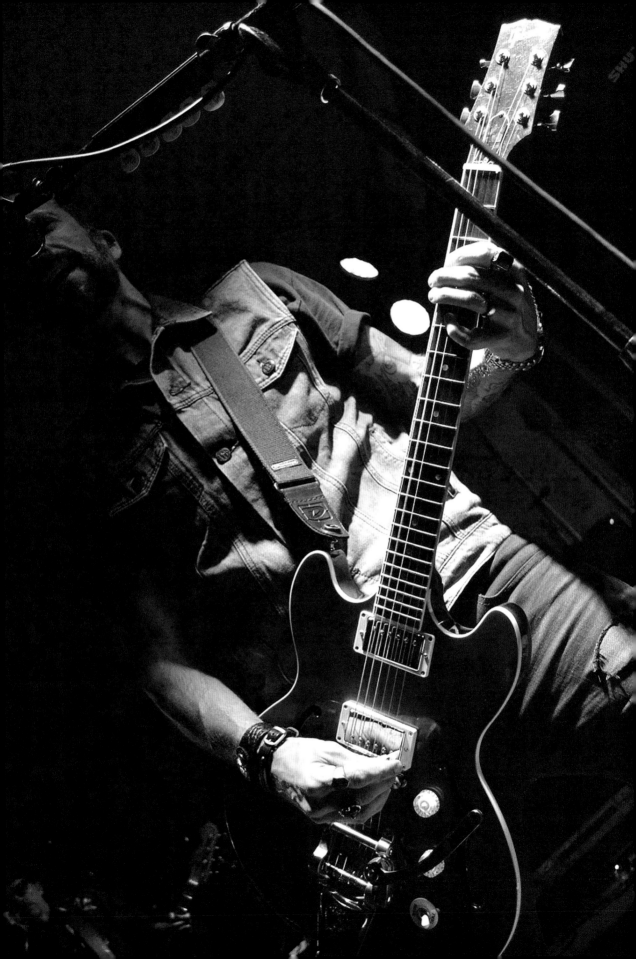

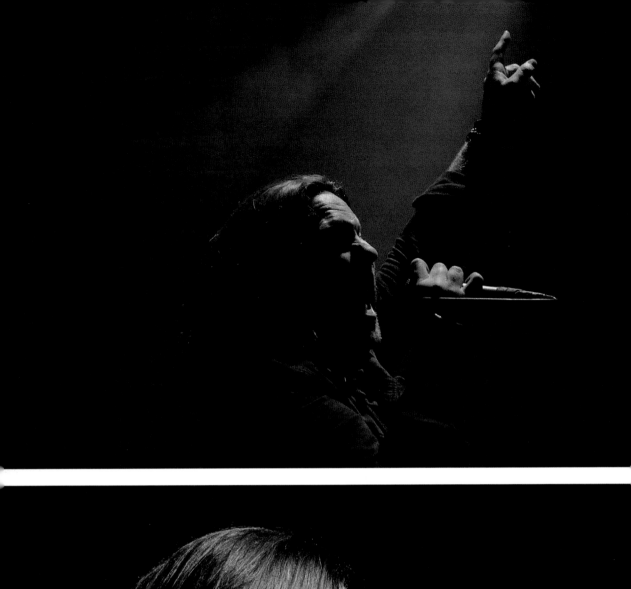
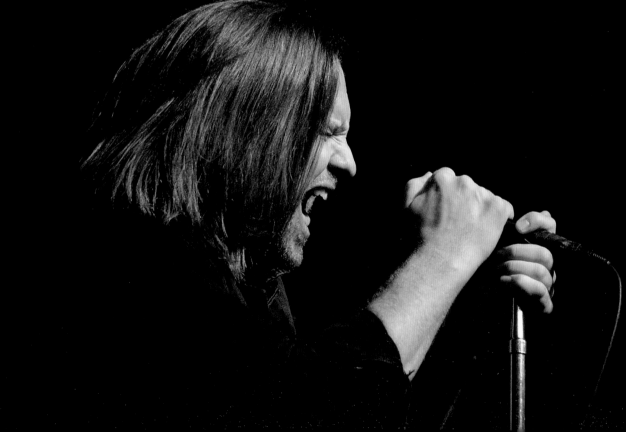

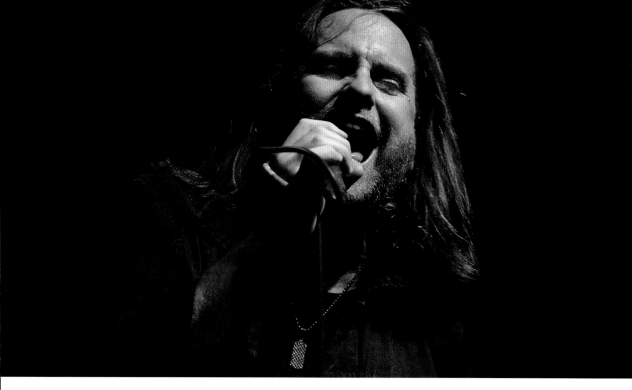

LAST IN LINE

Tower Theatre in Fresno, CA | January 18, 2019

FACING PAGE, TOP—There's something holy about this photo. That seems fitting, since most of the musicians in this band played with Ronnie James Dio and contributed to his definitive album *Holy Diver*. *(Andrew Freeman, lead vocals. NIKON D3200, ƒ/4, 1/160 second, 55mm, ISO 1600)*

FACING PAGE, BOTTOM—Try to capture the best photo you can in the moment. Your product shouldn't be defined by postproduction. I don't mind some improvements here and there, but the more changes you add, the more fake it becomes. It takes away from the honest essence of the shot. *(Andrew Freeman, lead vocals. NIKON D3200, ƒ/4.8, 1/125 second, 122mm, ISO 3200)*

ABOVE—Andrew Freeman has played with The Offspring and George Lynch's Lynch Mob. He knows how to rock. *(Andrew Freeman, lead vocals. NIKON D3200, ƒ/4.5, 1/200 second, 102mm, ISO 3200)*

"Most of the musicians in this band played with Ronnie James Dio and contributed to his definitive album *Holy Diver.*"

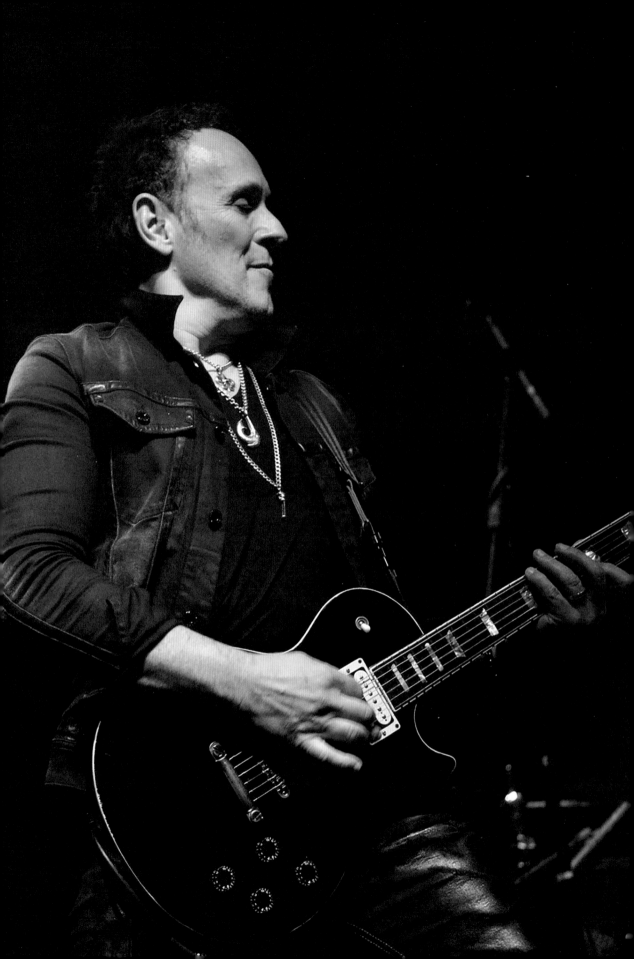

FACING PAGE—Vivian Campbell has been Def Leppard's rhythm guitarist ever since the passing of their original lead guitarist, Steve Clark, in 1991. In 2019, the band was inducted into the Rock 'N' Roll Hall of Fame. Last in Line performed around the time that honor was announced, so it was great to see a Hall of Fame guitarist shredding right in front of me. *(Vivian Campbell, lead guitar. NIKON D3200, f/4.2, 1/125 second, 72mm, ISO3200)*

RIGHT—Digital cameras allow you to choose your own way to snap a pic. If the subject is moving or if autofocus isn't fast enough, you can switch to manual focus to get the look you want. If the musicians are still, autofocus can frame the best image with good clarity. *(Vivian Campbell, lead guitar. NIKON D3200, f/4.2, 1/160 second, 68mm, ISO1600)*

BELOW—Vivian Campbell also contributed to Thin Lizzy and Whitesnake. That's a great resume. *(Vivian Campbell, lead guitar. NIKON D3200, f/4, 1/200 second, 18mm, ISO3200)*

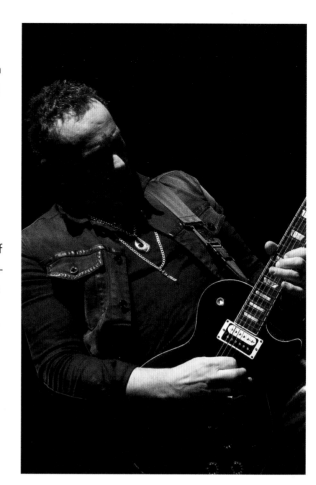

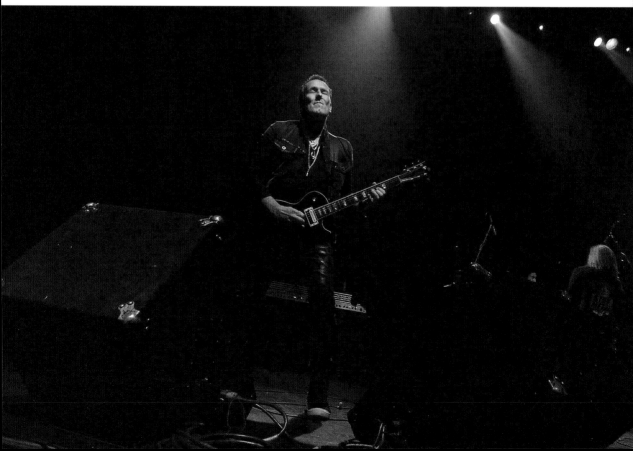

LOS LONELY BOYS

Fox Theatre in Visalia, CA | February 16, 2019

BELOW—All of the members are brothers. So, technically you can consider this a family portrait. *(NIKON D3200, ƒ/4.2, 1/100 second, 65mm, ISO3200)*

FACING PAGE, TOP—It's not common to see a whole band that looks like you. Being Hispanic myself, it is mesmerizing to see these guys playing rock and blues. Ever since their breakout hit "Heaven" (and a Grammy win for the song!) I've wanted to see them live—but I never got the chance until this night. *(Henry Garza, guitar. NIKON D3200, ƒ/4.8, 1/100 second, 116mm, ISO3200)*

FACING PAGE, BOTTOM—My images are normally stored and shared as JPEG files, a popular image format that can be easily opened by most computers. JPEG files also support user-determined compression to reduce file size for quicker upload and download. Contrast this with RAW files, as described in the next photo. *(Henry Garza, guitar. NIKON D3200, ƒ/4.5, 1/100 second, 90mm, ISO3200)*

"Being Hispanic myself, it is mesmerizing to see these guys playing rock and blues."

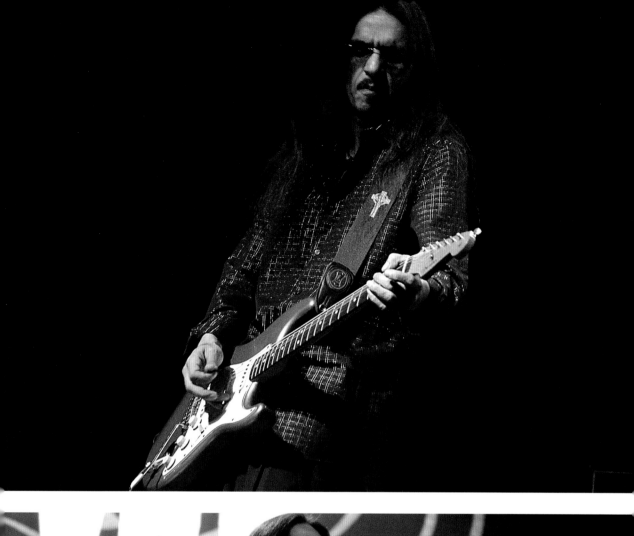
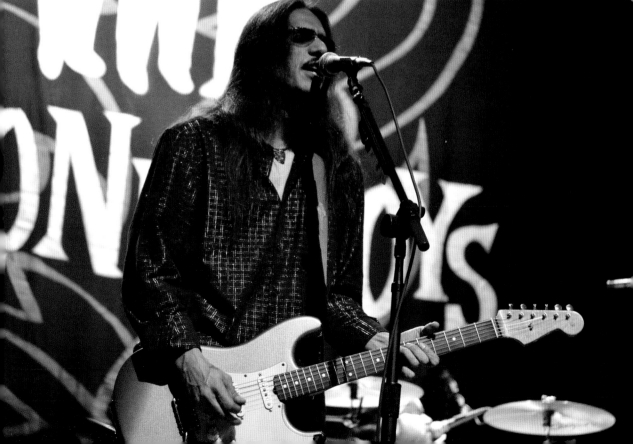

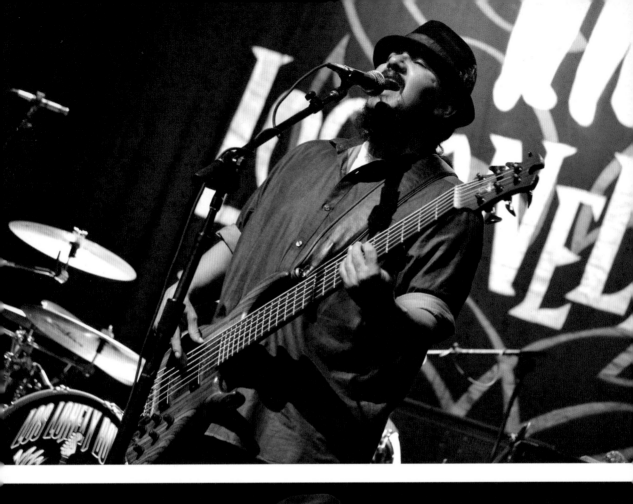
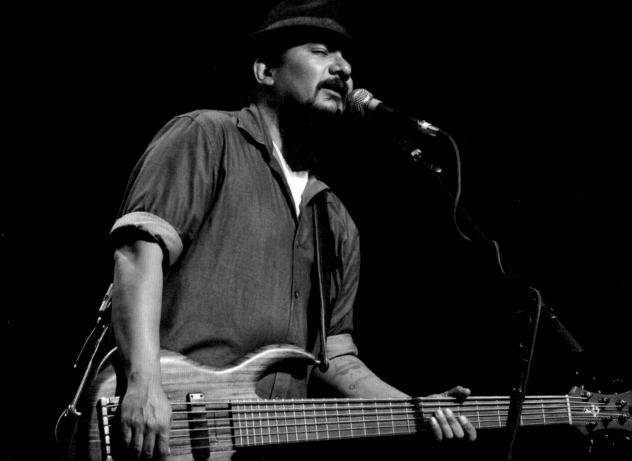

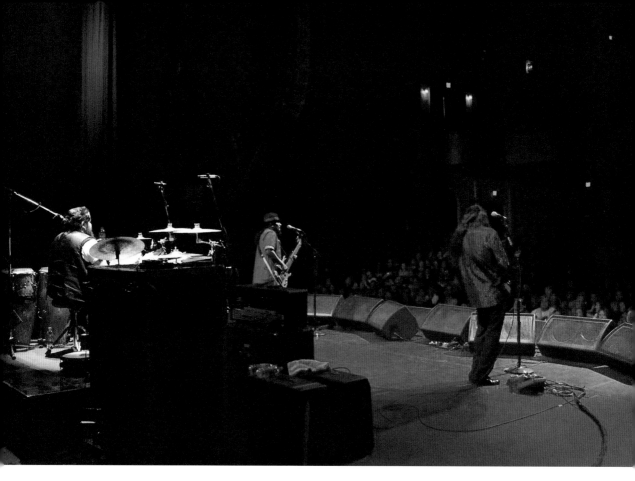

FACING PAGE, TOP—The RAW image format (unlike the JPEG format mentioned in the previous photo), remains uncompressed and contains all the unprocessed or undeveloped data from the image sensor of a digital camera. These files take up quite a bit of data and memory, but they offer the best quality for postproduction editing with programs like Photoshop. *(Jojo Garza, bass. NIKON D3200, f/4.2, 1/100 second, 85mm, ISO3200)*

FACING PAGE, BOTTOM—Never forget who you're representing—not only your publication and yourself, but also your community. You're a representative of the place where you operate. When you come in contact with managers, publicists, and the artists, always leave a good impression. You never know—maybe some of these artists will want to come back to your city because they remember how nice you were to them. Sometimes that's all

it takes. *(Jojo Garza, bass. NIKON D3200, f/4.8, 1/160 second, 120mm, ISO1600)*

ABOVE—A backstage photo of the band. Photographers rarely get access to shoot images like this; you have to either know someone or associate with the band personally. I was fortunate that the promoter let me take photos around the stage where I wanted to. It's about being at the right place at the right time—and this image epitomizes that. *(NIKON D3200, f/4, 1/100 second, 24mm, ISO3200)*

LOVELYTHEBAND

Tioga Sequioa Company in Fresno, CA | September 12, 2018

ABOVE—Just because it's an intimate acoustic show doesn't mean your efforts should be less than what you would do at a big arena spectacle. Treat every show with the same kind of enthusiasm. *(Mitchy Collins, vocals. NIKON D3200, ƒ/5.3, 1/100 second, 46mm, ISO1600)*

BELOW—Don't get complacent when people compliment you on your work. You can't let it get to your head because there's always room for improvement. The moment you feel content is the moment you lose the drive. Don't lose it. *(Jordan Greenwald, guitar. NIKON D3200, ƒ/5.3, 1/160 second, 175mm, ISO800)*

RIGHT—Take a photo class or teach yourself. With all the websites, video tutorials, and books on the market, no one is stopping you from learning this craft. Once you grasp the essentials, then go out and do it. *(Sam Price, drums. NIKON D3200, ƒ/4.5, 1/125 second, 30mm, ISO800)*

BELOW—The obvious hot-spots for live music are arenas, outdoor parks, and small clubs—but breweries are now also establishing themselves as destinations for concerts. *(Mitchy Collins, vocals. NIKON D3200, ƒ/4.5, 1/160 second, 98mm, ISO800)*

"Breweries are now also establishing themselves as destinations for concerts."

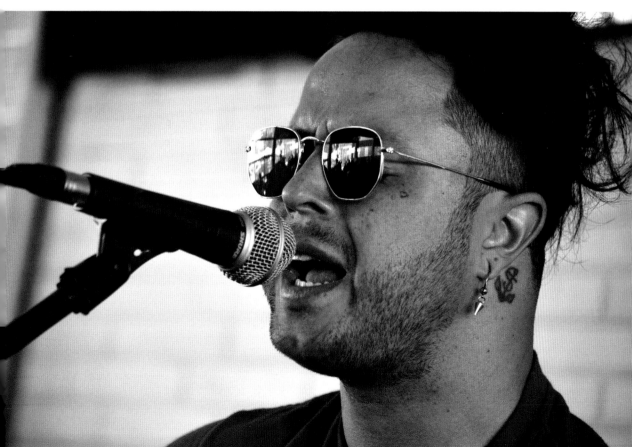

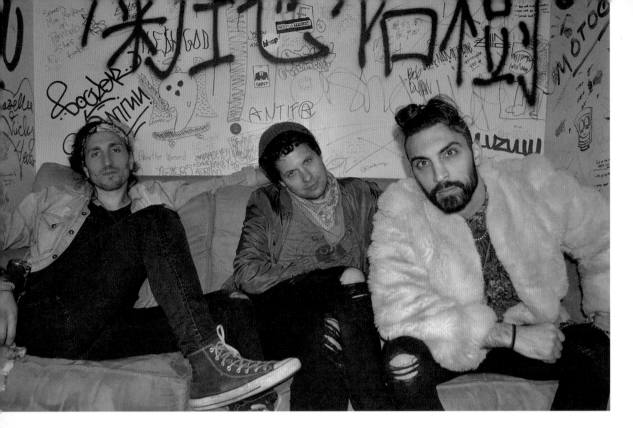

MAGIC GIANT

Strummer's in Fresno, CA | March 2, 2018

ABOVE—This was taken in the dressing room before the show. They are just as funny and energetic offstage as they are onstage. In fact, it was a challenge to keep a straight face during the interview! *(NIKON D3200, f/3.8, 1/30 second, 20mm, ISO800)*

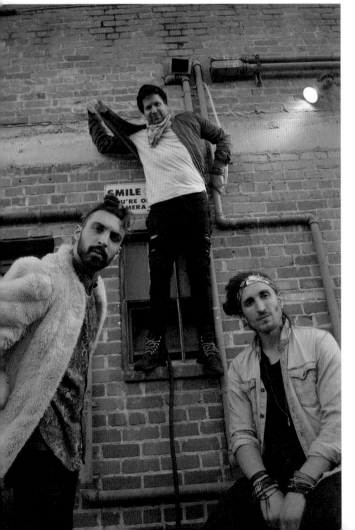

LEFT—I am most proud of this photo, taken outside the venue. It was like my Annie Leibovitz moment to photograph a band away from the stage—but they still have the same energy and appeal posing for a photo as they do when they're playing. Also, it's so much easier to have a band pose for you because you don't have to keep moving your camera around just to grab a shot. *(NIKON D3200, f/3.8, 1/50 second, 20mm, ISO100)*

RIGHT—Austin Bisnow hails from Washington, D.C. and is making waves as a songwriter and producer. He has collaborated with John Legend, David Guetta, and others. *(Austin Bisnow, vocals. NIKON D3200, f/4.2, 1/100 second, 700mm, ISO6400)*

BELOW—Magic Giant's music includes orchestral drums, banjo, trumpet, saxophone, harmonica, synthesizers, electric bass, cello, viola, violin, dobro, lap steel, and mandolin. "We have this palette of instruments to choose from and the song usually dictates the instrument. You can't get in the way of the song, and it's obvious when it's the right instrument," Zang says. *(Zang, acoustic guitar/cello. NIKON D3200, f/4.2, 1/100 second, 62mm, ISO6400)*

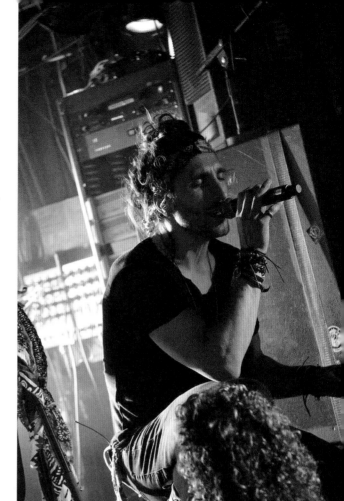

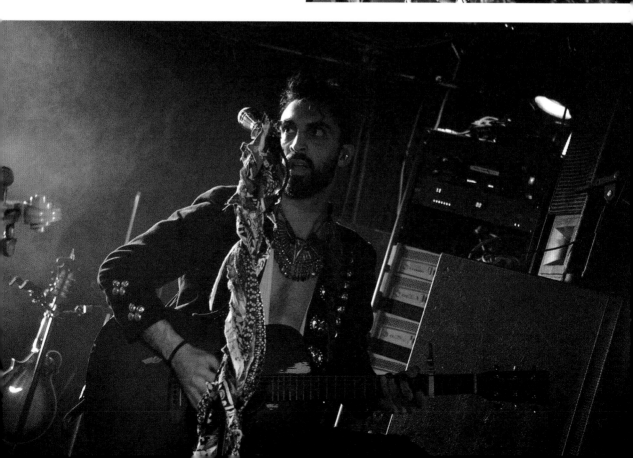

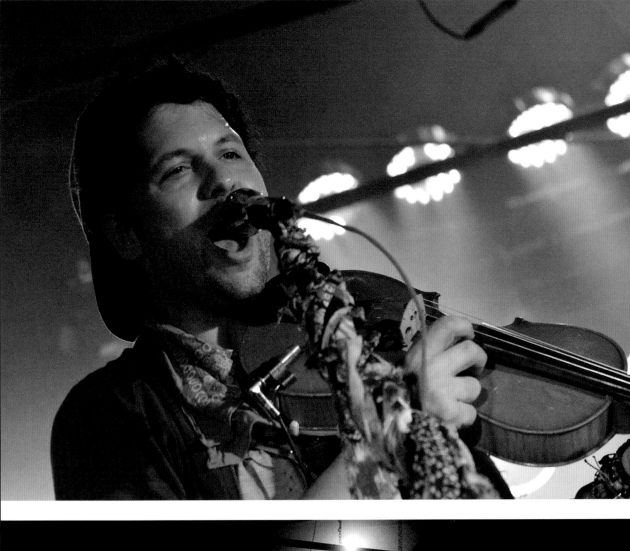

FACING PAGE, TOP—Zambricki taught himself the violin in a matter of four days after being in a coma due to a car accident when he was 12 years old. That accident resulted in him having Acquired Savant Syndrome. *(Zambricki Li, viola/ banjo/ harmonica. NIKON D3200, f/4.2, 1/100 second, 82mm, ISO6400)*

FACING PAGE, BOTTOM—"What I like about this group is our voice feels like this vague fourth person, a spirit animal that we've created through our voices that I feel is true to us," says Zang. "It doesn't sound like my voice, or anyone specifically in the band. It's a different being where I can picture this different animal that is speaking on our behalf, and I'm not sure if other people have that similar experience where there's this collaboration of mind flow or something." *(NIKON D3200, f/4.2, 1/100 second, 82mm, ISO6400)*

BELOW—In regards to their success, Zambricki says, "I don't necessarily think it means one thing. We're just out here trying to make the best music

we can, have a good time, connect with the fans, and have a real experience." *(Austin Bisnow, vocals. NIKON D3200, f/4, 1/100 second, 20mm, ISO6400)*

"What I like about this group is our voice feels like this vague fourth person, a spirit animal that we've created through our voices that I feel is true to us," says Zang.

NOTHING BUT THIEVES

Tioga Sequioa Company in Fresno, CA |
March 16, 2018

BELOW—Action is what separates concert photography from other specialties. In landscape photography, the forest won't move; with fashion photography, the model gets paid to stand there as long as needed to get the image that satisfies the photographer. Live music photographers don't get that luxury—but in the end, you should cherish the fact. You'll capture something real and honest in the moment. *(Connor Mason, lead vocals. NIKON D3200, ƒ/5.3, 1/125 second, 160mm, ISO 1600)*

"You'll capture something real and honest in the moment."

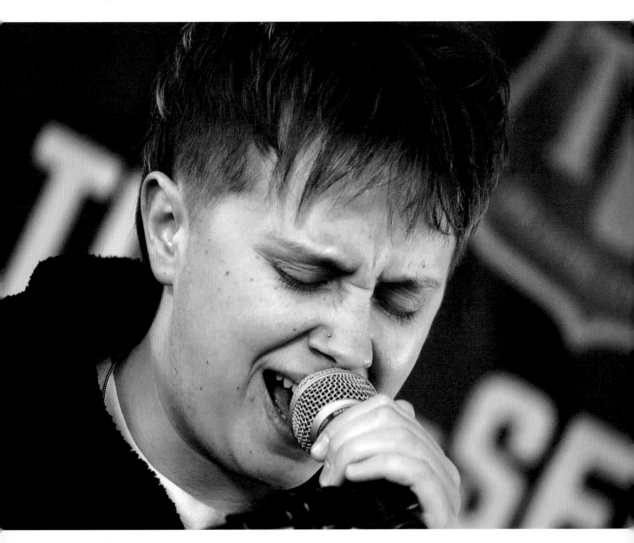

BELOW—Always learn from the greats. I'm an admirer of my predecessors such as Mick Rock, Annie Leibovitz, Bob Gruen, Jim Marshall, Michael Zagaris, and Kevin Mazur. They inspire me and I either see ways that I can incorporate their style into mine or I see what I can do differently from them. Be inspired by them, but don't aspire to be them, be your own person and be great at what you bring to the table. *(Dom Craik, guitar. NIKON D3200, ƒ/4.2, 1/125 second, 75mm, ISO 1600)*

"Be your own person and be great at what you bring to the table."

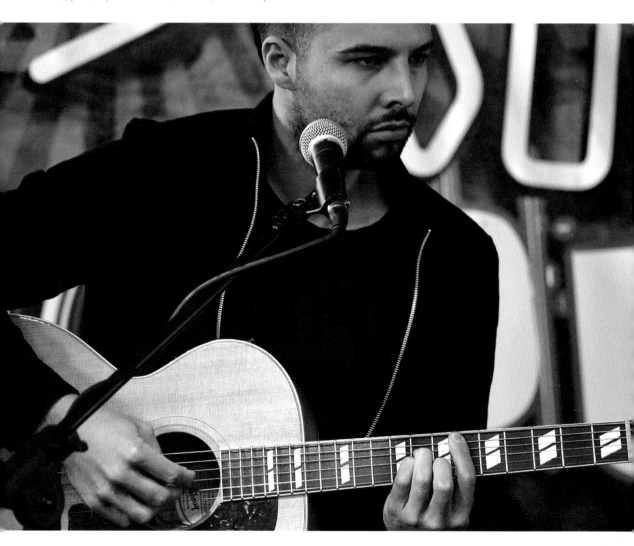

PHIL ANSELMO & THE ILLEGALS

Strummer's in Fresno, CA | November 10, 2018

BELOW, LEFT—Philip H. Anselmo is the legendary and former frontman of the heavy metal juggernaut Pantera. He brought his current band, The Illegals, to Fresno and this tour is to support their second album, *Choosing Mental Illness As a Virtue*. For Phil, this is another entry in the huge discography and storied career of the metal idol. *(Phil Anselmo, vocals. NIKON D3200, ƒ/5.3, 1/125 second, 165mm, ISO 1600)*

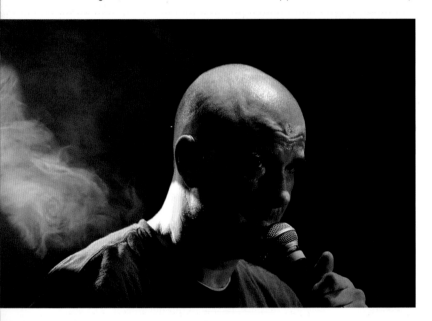

BOTTOM—Explore the venue's space as much as you can. Don't assume one side is better than the other. The stage is your studio, so use it. Go stage left, or right, or in the middle. Don't be limited. Some crowds may be congested to the point where you can't move or you may only be given a certain amount of time to snap away (in which case, you might not want to waste it walking from place to place). Otherwise, this is your world—own it. *(Phil Anselmo, vocals. NIKON D3200, ƒ/5, 1/160 second, 135mm, ISO 1600)*

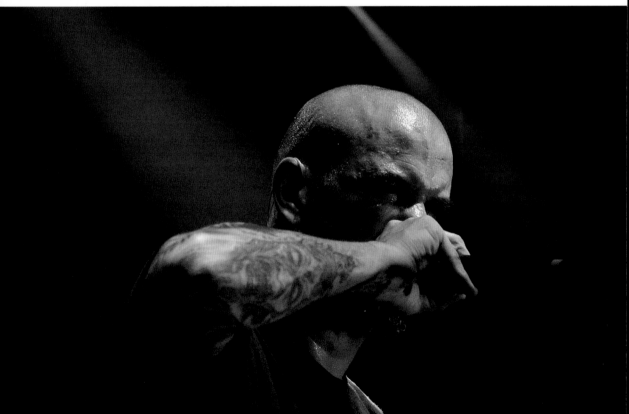

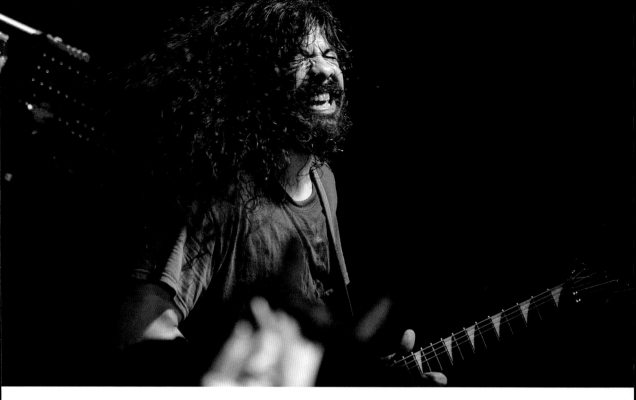

ABOVE—"Being in front of the fans' faces, it's cool playing these smaller shows. When you're here in some of these smaller spots, you get to jam in front of the fans, and you give them your energy and they give it back, so it makes it intimate and personal," says Mike DeLeon. *(Mike DeLeon, lead guitar. NIKON D3200, f/4.2, 1/160 second, 86mm, ISO 1600)*

just trying to enjoy the show and couldn't care less why you're there. People might get shoved into you, beer or water might get thrown at you—from the stage or the crowd. Learn to shield that camera as best you can; that's priority number one. *(Phil Anselmo, vocals. NIKON D3200, f/5, 1/160 second, 135mm, ISO 1600)*

RIGHT—Protect your camera at all costs. That's your baby, your livelihood—and, believe me, you don't want it to get broken. These are rock shows, so you're dealing with people who are inebriated (whether it be through chemicals or liquids) and have a lack of judgment. They are

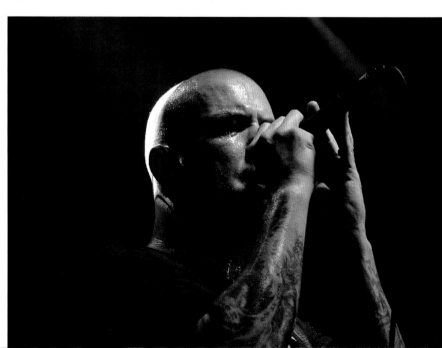

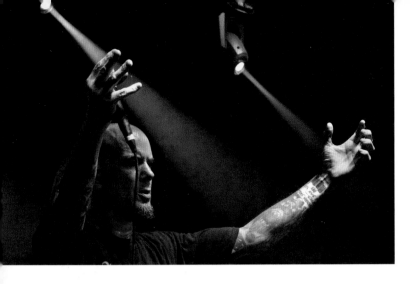

LEFT—Photography requires stamina. Concerts last for several hours, most of the time you're on your feet, the media pit is right in front of the speakers, and you're carrying your equipment everywhere. It can take a toll on you physically—but the better shape you are in, the more shows you can do. *(Phil Anselmo, vocals. NIKON D3200, ƒ/4.5, 1/160 second, 98mm, ISO1600)*

P.O.D.

Full Circle Brewing Company in Fresno, CA | September 8, 2018

BELOW—At some point in the night, members of the preceding bands and the roadies all played a game of cornhole on stage—while P.O.D was performing! *(Marcos Curiel, lead guitar. NIKON D3200, ƒ/3.8, 1/200 second, 22mm, ISO1600)*

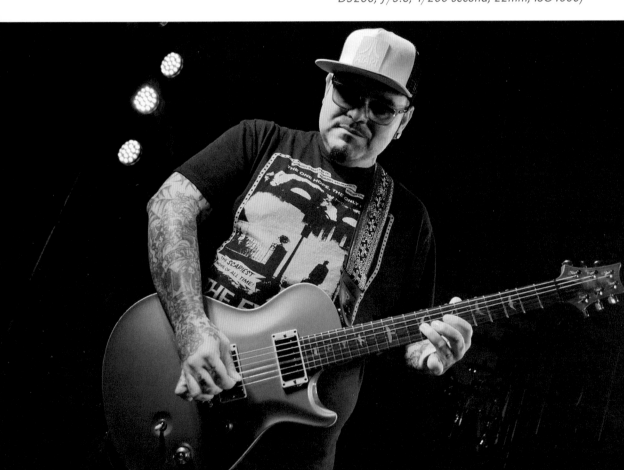

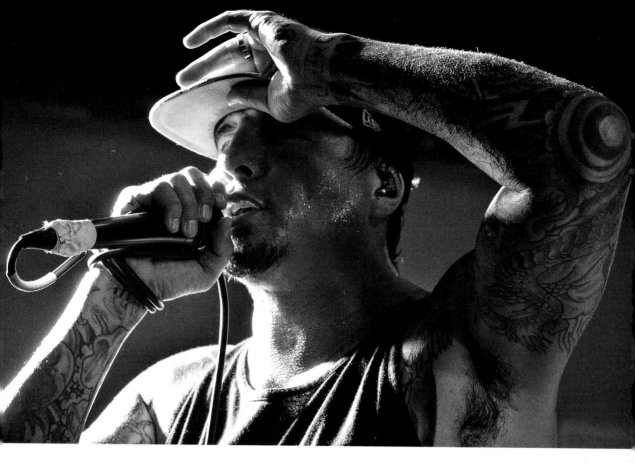

ABOVE—P.O.D. is the band that I would listen to when working out or getting pumped before football games. I had an emotional connection to this band when I was younger, and the songs brought me back to the times of my past. Getting the chance to meet Sonny after the show meant a great deal to me. *(Sonny Sandoval, vocals. NIKON D3200, f/4.2, 1/125 second, 86mm, ISO 1600)*

RIGHT—While playing "Youth of a Nation," Sonny called up all the kids who were in the audience to line up on the stage. He then dedicated this song to them, since they will become "the leaders of tomorrow." He said that he expects them to "do good in the world." *(Sonny Sandoval, bass. NIKON D3200, f/3.5, 1/125 second, 18mm, ISO 1600)*

"It's not every day that you get to see a heavy metal band race go-karts."

POP EVIL

MB2 Raceway in Fresno, CA | March 24, 2016

FACING PAGE, TOP—It's not every day that you get to see a heavy metal band race go-karts. It's really gratifying to see a side of these musicians that the average fan doesn't get the chance to witness. *(Apple iPhone 4, f/2.8, 1/15 second, 3.85mm, ISO 1000)*

FACING PAGE, BOTTOM LEFT—You can say that go-kart racing is very similar to metal. They're both loud and fast. No wonder why there's an attraction. Maybe that's the reason why the saying "putting the pedal to the metal" exists? *(Matt DiRito, bass. Apple iPhone 4, f/2.8, 1/15 second, 3.85mm, ISO 1000)*

FACING PAGE, BOTTOM RIGHT—Cell phone cameras are cool because their resolution gets better with each upgraded model that comes out, meaning you can capture higher definition photos. But beyond that, cell phone cameras don't compare to the focal length and array of shooting options available on a DSLR. You can also be guaranteed that all the attendees of an event will have cell phone cameras—but you, you're the professional. Having professional equipment with you lets people know who you are and sets your images apart. Nowadays, the lines have been blurred between amateurish and professionalism in certain fields. But when it comes to concert photography, to be a professional you have to present yourself as a professional. *(Leigh Kakaty, lead vocals. Apple iPhone 4, f/2.8, 1/15 second, 3.85mm, ISO 1000)*

ABOVE—I play pool, too. I would have challenged him, but I was content just to photograph him. *(Nick Fuelling, lead guitar. Apple iPhone 4, f/2.8, 1/15 second, 3.85mm, ISO 800)*

"Cell phone cameras don't compare to the focal length and array of shooting options available on a DSLR."

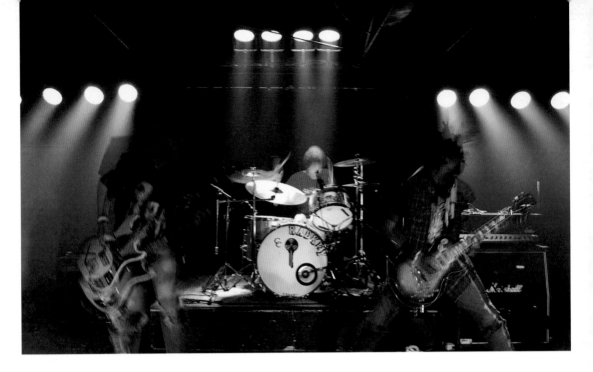

RADKEY

Strummer's in Fresno, CA | June 28, 2017

ABOVE—It's an honor to photograph the evolution of music. A band like this wouldn't previously have been accepted in the world of rock, but now times have changed—and your photographs can embody that change. All three of them are brothers and they are changing the way we see the genre of rock. *(NIKON D3200, ƒ/3.5, 1/4 second, 18mm, ISO800)*

BELOW—Some nights, it seems like every shot is amazing; other nights, you feel like you got nothing. Don't get discouraged. This is the most challenging kind of photography out there. If you only get one good shot, that's still something to be proud of. That's why you keep going to shows—so you get better. Whether you got a lot of good images or a few, just capturing the moment is all that matters in the end. *(Solomon Radke, drums. NIKON D3200, ƒ/3.8, 1/50 second, 20mm, ISO3200)*

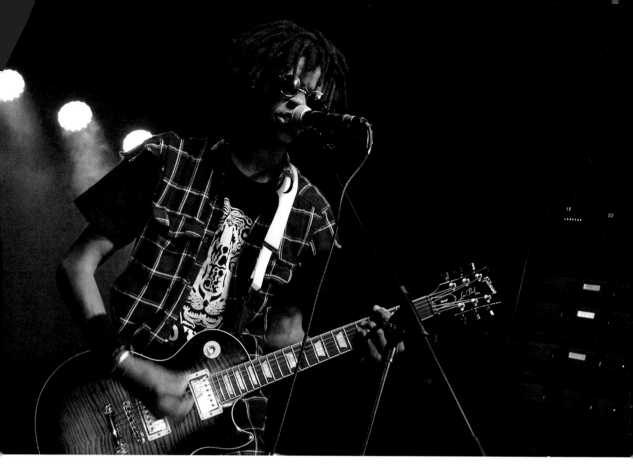

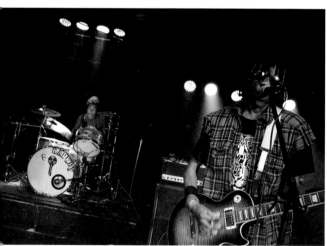

ABOVE—No matter how good your work is, people will criticize you. Like every artist before us, we are all protective of our work and the slightest critique can make you feel like a failure. If you keep doing what you're doing, you'll improve with time and patience. *(Dee Radke, lead vocals. NIKON D3200, f/5, 1/100 second, 35mm, ISO6400)*

LEFT—As a photographer, you're a natural preservationist and, as time goes by, a historian. When people reflect back on a band's career or images that embody a certain point in time, they'll almost always be using photographs for reminiscing. Every time you click away, you're capturing a moment in time and the person in your photo will live forever. Now that's power. *(NIKON D3200, f/3.8, 1/60 second, 20mm, ISO3200)*

"As a photographer, you're a natural preservationist and, as time goes by, a historian."

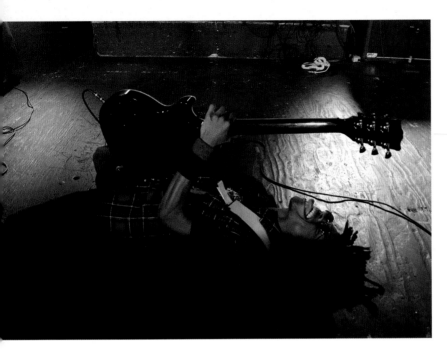

LEFT—There are many kinds of music-related photography besides the live shows. There can be a good amount of time in between shows, so you should do something to continue working on your craft. There's band photography for their press kit, studio photos, etc. Adding skills like videography and journalism to your arsenal will also draw more people to your work. *(Dee Radke, lead vocals. NIKON D3200, f/3.5, 1/80 second, 18mm, ISO3200)*

SALIVA

The Wakehouse in Reedley, CA | December 9, 2017

BELOW—The shutter speed determines the length of time that light enters your camera. Slow shutter speeds admit more light and will record more movement, but that movement can become blurry. Faster shutter speeds admit less light and freeze your subject. *(Brad Stewart, bass. NIKON D3200, f/4.2, 1/100 second, 80mm, ISO3200)*

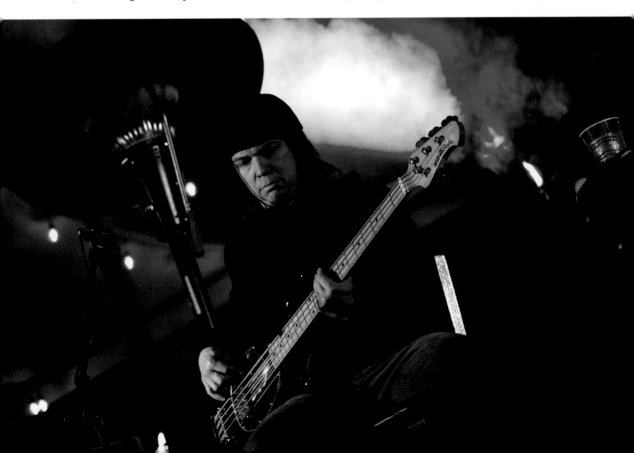

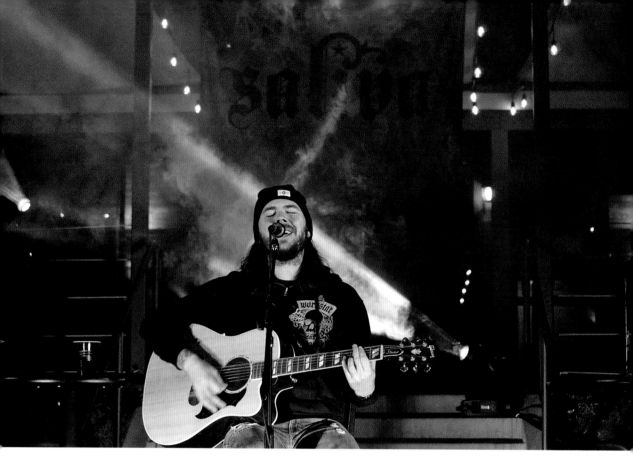

ABOVE—If you know you're doing an outdoor show, it's best you check the forecast. How you react to weather can be evident in your photos. If it's hot, then your photos can express your fatigue; if it's cold, your photos can turn out unbalanced. This December night it was pretty chilly, but I dressed for the occasion. If you prepare for the conditions where you'll be shooting, your photos will thank you. *(Bobby Amaru, lead vocals. NIKON D3200, f/4, 1/100 second, 55mm, ISO3200)*

RIGHT—The ISO setting controls how sensitive your camera is to light. The higher the ISO, the more sensitive it becomes. This is good for darker conditions, but produces more image noise. The lower the ISO is set, the less sensitive it becomes to light. This is good for brighter conditions and yields less image noise. *(Wayne Swinny, lead guitar. NIKON D3200, f/4.5, 1/100 second, 100mm, ISO3200)*

SHAMAN'S HARVEST

Fulton 55 in Fresno, CA | September 7, 2017

BELOW—How do you get media access to these concerts? It's not as easy as it used to be. I hear stories that in the '70s and '80s, people were more lenient. You could sneak a camera into a show and take photos in the crowd as a regular concert-goer and not too many people treated it as a big deal. That's not the case any more. The following are some ways to get into these shows as a photographer. *(Nathan Hunt, lead vocals. NIKON D3200, f/5.3, 1/100 second, 40mm, ISO3200)*

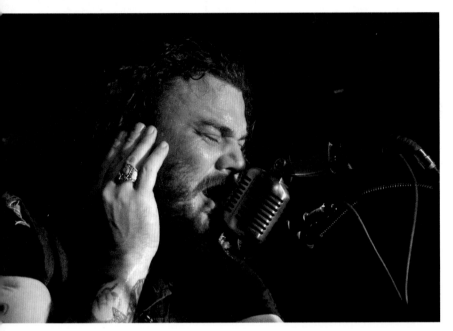

BOTTOM—First, get to know the promoter or promoters who are putting on local shows and offer to photograph the concerts on their behalf. *(Derrick Shipp, lead guitar. NIKON D3200, f/3.5, 1/80 second, 18mm, ISO3200)*

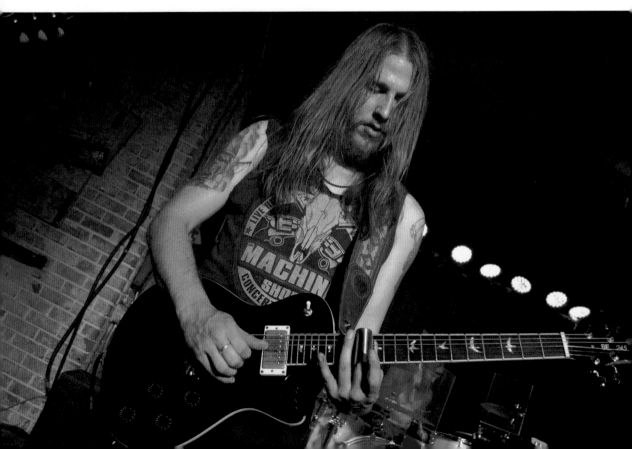

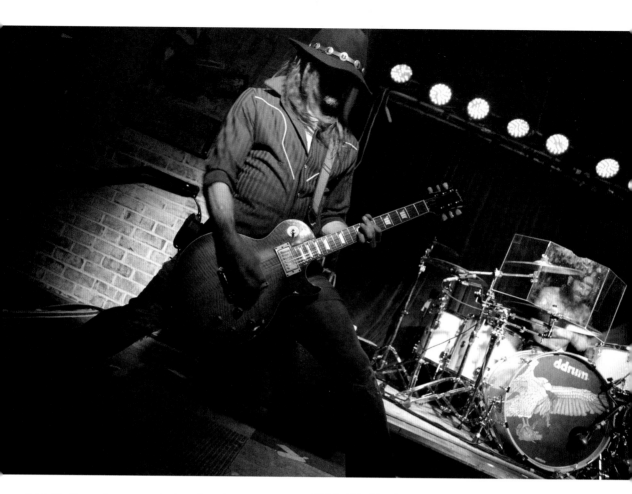

ABOVE—Second, contact the band or the artist's representatives. You can usually find that contact information on the band's website or their social media. I prefer e-mail for making contact with the artist or their representatives. *(Josh Hamler, rhythm guitar. NIKON D3200, f/3.5, 1/80 second, 18mm, ISO3200)*

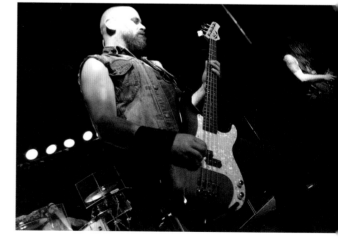

RIGHT—Third, try to become affiliated with a publication. Today, that doesn't mean just print media, like your local newspaper. There are independent magazines, online publications, and other outlets like blogs, vlogs, and podcasts. If they specialize in music coverage, let them know you're the person for the job and you'll shoot the show as a representative for them. *(Matt Fisher, bass. NIKON D3200, f/3.5, 1/100 second, 18mm, ISO3200)*

"If they specialize in music coverage, let them know you're the person for the job."

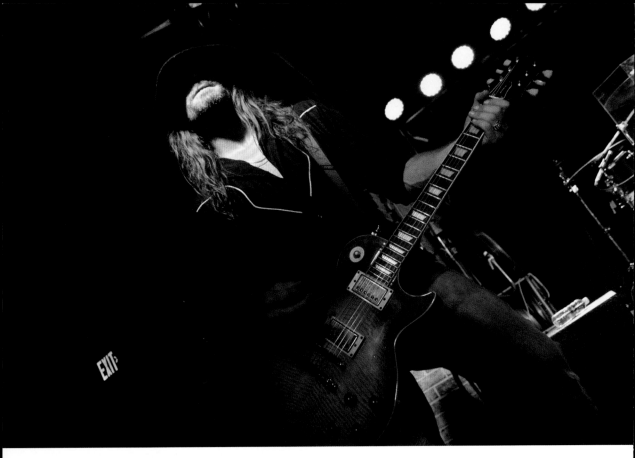

ABOVE—Another way (this is number five; see previous pages for more!) to get permission for photography is to get close with the people who run the venues that host these shows. *(Josh Hamler, rhythm guitar. NIKON D3200, ƒ/3.5, 1/80 second, 18mm, ISO3200)*

LEFT—Number six? Get in touch with the opening band or bands to see if they can put you on the guest list as their official photographer for the show. More than likely, that will allow you access throughout the entire lineup—so you can photograph all the opening acts and the headliner. *(Josh Hamler, rhythm guitar. NIKON D3200, ƒ/3.5, 1/100 second, 18mm, ISO3200)*

"See if they can put you on the guest list . . ."

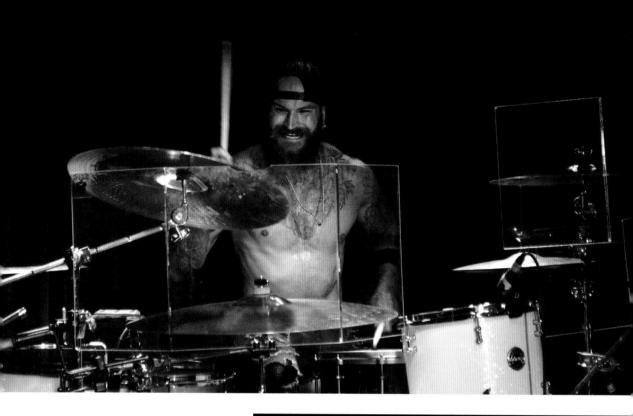

ABOVE—Idea number seven is to become acquainted with the local radio stations. Often, they host, put on, or attend these shows—and they use the Internet and social media to show their listeners that they go to concerts. Let them know you're a concert photographer and that they can use your photos. There's a chance they'll put you on a guest list and you can independently take photos for them. Whether it's a paying job or not, in the end you'll have an outlet to distribute your photos. *(Adam Zemanek, drums. NIKON D3200, f/5.6, 1/100 second, 55mm, ISO3200)*

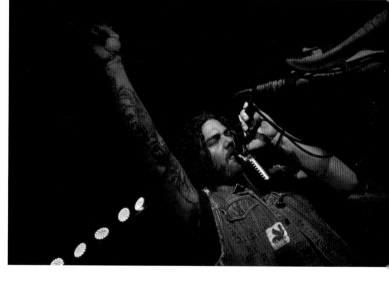

RIGHT—If the show is at a club or small venue, they are likely to be very lenient about photography, compared to a large outdoor concert or an arena show. At large venues, you'll likely be limited to photographing just three songs—and sometimes less than that. A photographer I know reported that one classic rock band only gave him 30 seconds! *(Nathan Hunt, lead vocals. NIKON D3200, f/4, 1/100 second, 24mm, ISO3200)*

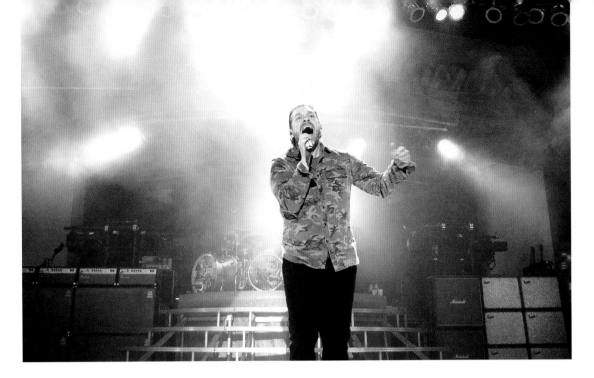

SHINEDOWN

Paul Paul Theatre in Fresno, CA | April 8, 2017

ABOVE—The rules for this show? Three songs and no flash. Some artists and representatives are nice enough to let you shoot the whole show, but it depends on the popularity of the performer and the particular venue. *(Brent Smith, lead vocals. NIKON D3200, ƒ/4, 1/100 second, 24mm)*

BELOW—Also, a reminder: you're at the show for picture-taking, but the hundreds or thousands of people in attendance are there to watch the show. Do the best you can to stay out of their way. Be courteous and don't ruin their experience. The last thing you want is to tangle with an unhappy audience member. *(Eric Bass, bass. Barry Kerch, drums. NIKON D3200, ƒ/5.6, 1/200 second, 55mm)*

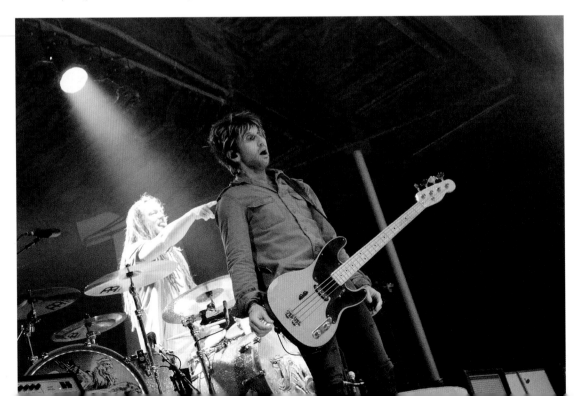

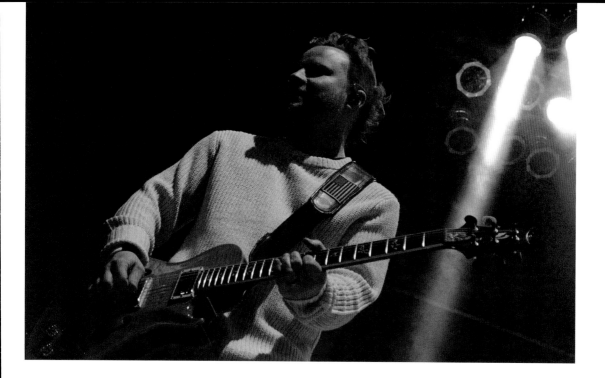

ABOVE—When choosing photographs to put out there, look for the ones with character—the ones that evoke a mood or feeling. They may not be clear or distinct or in high definition, but something about them makes you want to keep looking. Choose the ones you can't take your eyes off. *(Zach Myers, guitar. NIKON D3200, ƒ/5.3, 1/160 second, 44mm)*

BELOW—At some point, stop taking photos and enjoy the show! You're there because you're a lover of the music first and foremost. Sometimes you can get so caught up in the photography that you forget to take in the experience of the performance. It's a spectator event meant for excitement—so revel in it. Besides, your camera can use a break every now and then. *(Brent Smith, lead vocals. NIKON D3200, ƒ/5.6, 1/80 second, 55mm)*

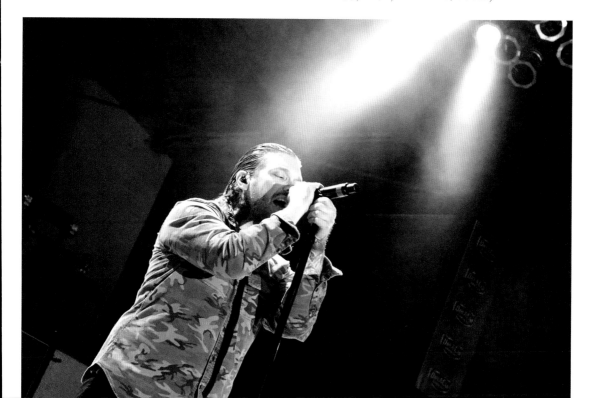

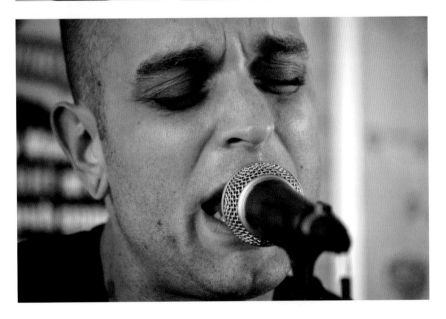

SIR SLY

Tioga Sequoia Brewing Co. in Fresno, CA | July 16, 2018

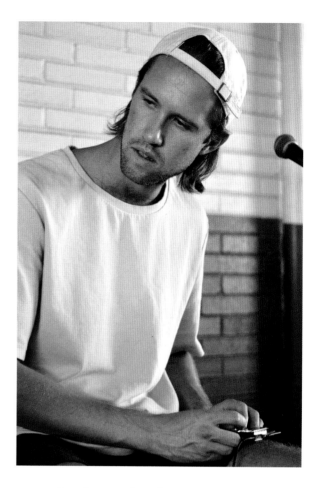

FACING PAGE, TOP—Before the Internet, if your photos weren't published by a newspaper or a magazine, they would never be seen. Today, there are so many ways in which to distribute your photos! With social media (Facebook, Instagram, Twitter, etc.) and a website that caters to your photos, you're your own content creator. In an instant, you can have your work up and start spreading the word about what you do. *(NIKON D3200, f/3.5, 1/160 second, 198mm, ISO800)*

FACING PAGE, CENTER—Your photos can help define a band visually. People may turn to your photos to see what the artists look like or what happened at the concert. It's rewarding when a photo that you took becomes synonymous with the identity of the band or artist. Documentary filmmakers, magazines, and book publishers, may come to you for an image. As time goes on, your photo can become the defining visual aid. *(Jason Suwito, keyboard. NIKON D3200, f/4.5, 1/160 second, 110mm, ISO800)*

FACING PAGE, BOTTOM—I've had plenty of people see my work and say, "I didn't know that band or person was in town!" Therefore, I've made it a priority to be there and spread awareness of the music scene in my area. My images have brought bands to people's attention—and now these people are listening to them. You can influence people to want to buy the records and go to their concerts. *(Landon Jacobs, lead singer. NIKON D3200, f/4.5, 1/250 second, 90mm, ISO1600)*

ABOVE—Concert photography can be a good way for you to be exposed to what's taking place out there in the scene—new bands and new trends. Before this, I had never seen somebody play drums on a contraption that is the size of a bar of soap! *(Hayden Coplen, drums. NIKON D3200, f/4, 1/200 second, 55mm, ISO1600)*

"Before the Internet, if your photos weren't published by a newspaper or a magazine, they would never be seen."

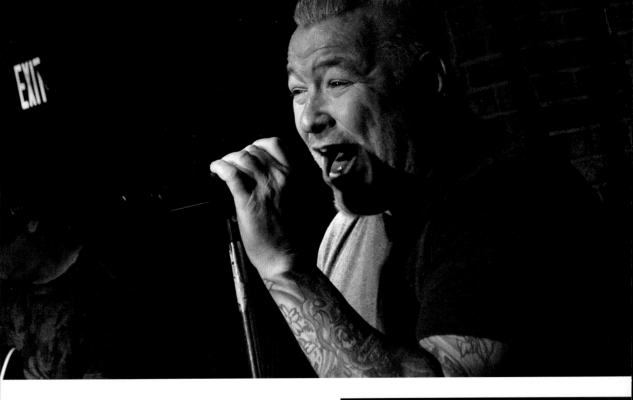

SMASH MOUTH

Fulton 55 in Fresno, CA | August 23, 2017

ABOVE—This band played like all stars (pun intended—remember their seminal hit "All Star"?)! Before photographing a concert, you should know the band's popular songs and when the verse, chorus, and guitar solo will occur. That way, you'll be prepared to capture images of that priceless moment. *(Steve Harrell, lead vocals. NIKON D3200, f/5.6, 1/60 second, 55mm, ISO3200)*

RIGHT—Do some research about the band before the concert. Are there any gimmicks or planned things they do that you know would make for a good photo? They may or they may not—but if they do, you'll want to be ready to capture that image. *(Steve Harrell, lead vocals. NIKON D3200, f/5.3, 1/60 second, 44mm, ISO1600)*

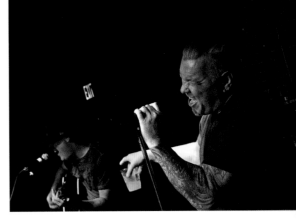

FACING PAGE, TOP—Smash Mouth started out as a punk band, so it was different to see them playing familiar songs in an upbeat tempo and doing covers of songs that I didn't think they would do. It's good to see a band in a different light than the way you're used to seeing them. *(Kristian Attard, bass. NIKON D3200, f/4, 1/50 second, 22mm, ISO3200)*

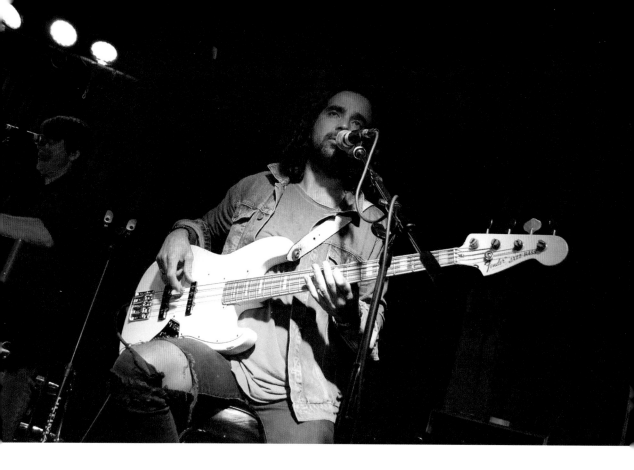

STARSET

Fulton 55 in Fresno, CA |
January 29, 2017

FACING PAGE—Dustin Bates describes the band as being "cinematic rock" and after seeing their show I agree with that. Laser lights, band members dressed in space suits—it was epic. Imagine if *2001: A Space Odyssey* mixed with *Star Wars* resulting in a rock opera hybrid. It would be this band. *(Dustin Bates, lead vocals. Apple iPhone 7, f/1.8, 1/145 second, 3.99mm, ISO20)*

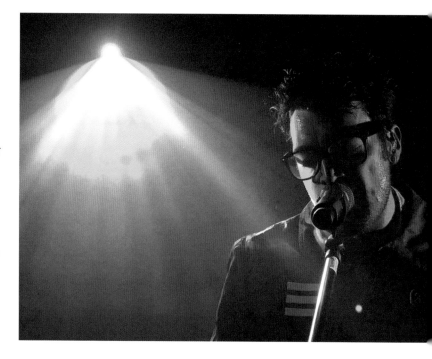

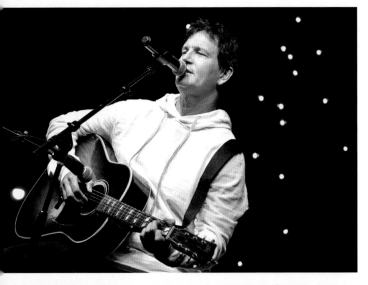

STEPHAN JENKINS OF THIRD EYE BLIND

"Camp Janz" in Clovis, CA | November 1, 2018

TOP LEFT—This was the first political endeavor I was a part of. Andrew Janz, the Democratic congressional candidate who challenged Republican Devin Nunes for California's 22 District seat, hosted an intimate event called the "Get Out The Vote Concert" for his supporters with a live acoustic performance from Stephan Jenkins, the lead singer for Third Eye Blind. *(NIKON D3200, f/4.5, 1/200 second, 102mm, ISO800)*

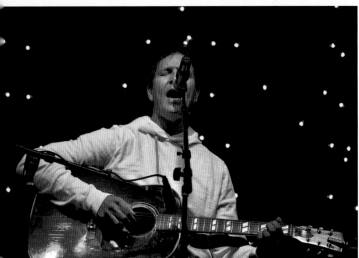

CENTER LEFT—"It's important for me to use my voice in whatever way I have it. Each musician must decide what is right for them to do, but I think music is a unifying force that creates a sense of community, and it's natural for me to believe that it extends into causes," said Jenkins. *(NIKON D3200, f/4.2, 1/500 second, 82mm, ISO800)*

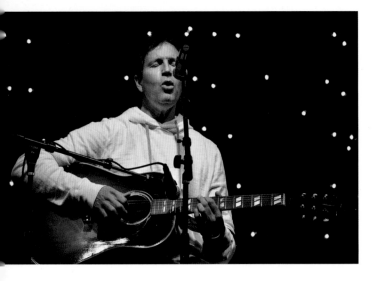

BOTTOM LEFT—That's the beauty of music: getting the opportunity to be involved in something that goes beyond the stage. I enjoy seeing musicians stand up for what they believe in and using their platform to express how they feel about the world. *(NIKON D3200, f/4.5, 1/250 second, 102mm, ISO800)*

FACING PAGE—"I say what I think and I'm not in it for commerce. I'm really into it to express myself and stand up for what I believe in. And if you're down with that, great," Jenkins said. *(NIKON D3200, f/4.2, 1/500 second, 82mm, ISO800)*

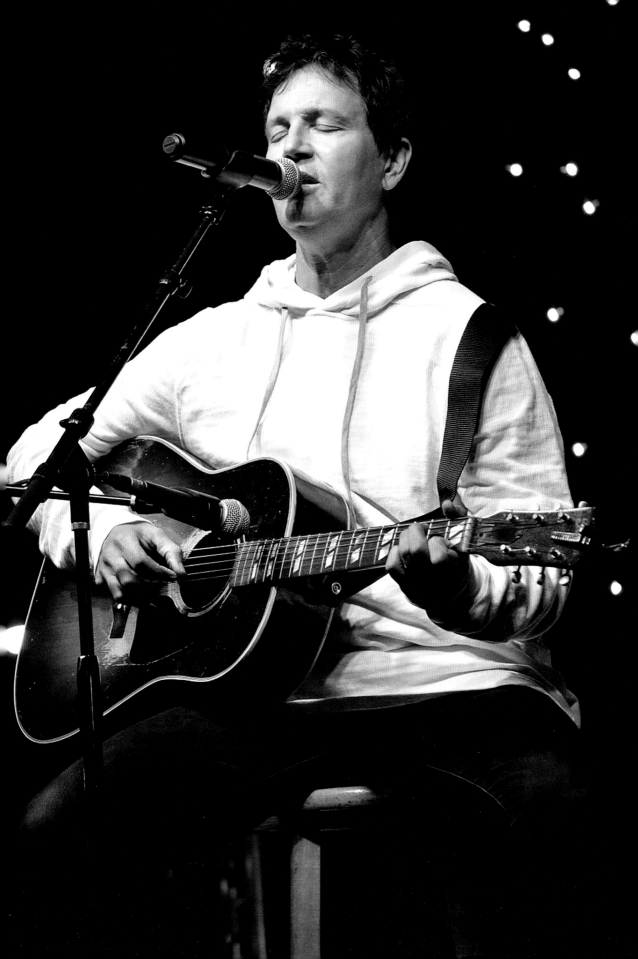

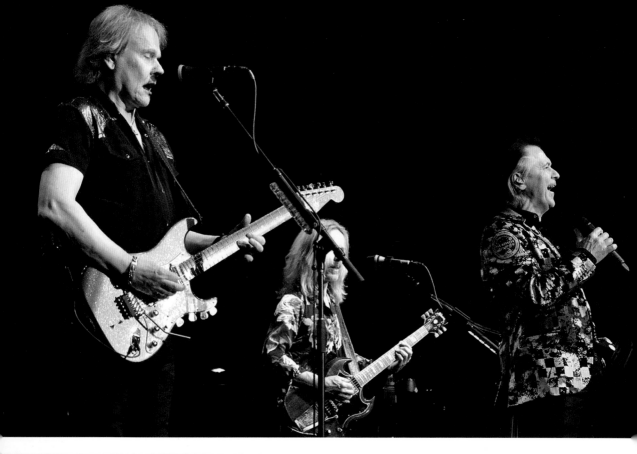

STYX

Fox Theatre in Bakersfield, CA | January 15, 2019

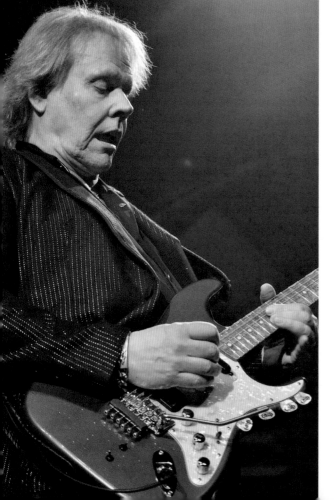

ABOVE—This show was big time for me. The '70s and '80s arena rock "renegades" were on tour for their sixteenth studio album, entitled *The Mission*. They've been in the business for over forty years! This was the first show in a long time that they played "Mr. Roboto." *(NIKON D3200, f/4, 1/250 second, 55mm, ISO 1600)*

LEFT—Their records contain progressive subjects and science fiction themes. So, what's their attraction to these high concepts and otherworldly ideas? "We've probably just seen too many episodes of *Star Trek*," James says with a laugh. "*The Grand Illusion* came out in the same year that *Close Encounters of the Third Kind* and *Star Wars* [did], so we kind [of] became the outer space band unintentionally." *Note:* James has a background

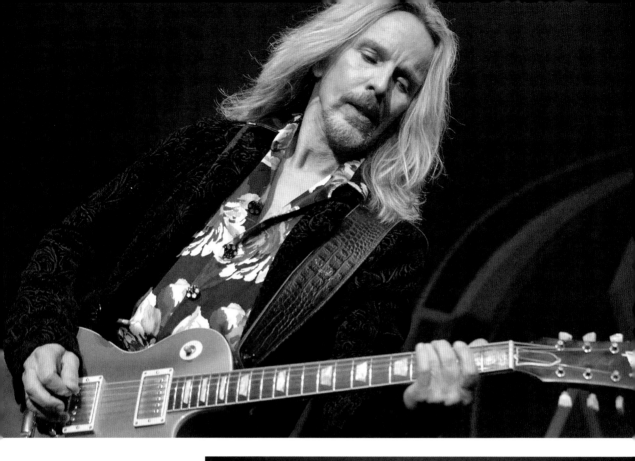

in aerospace engineering, so maybe that also helps. *(James "JY" Young, vocals/lead guitar. NIKON D3200, f/4, 1/200 second, 55mm, ISO 1600)*

ABOVE—Tommy Shaw has been a major contributing singer and songwriter to the band for a long time—and it's why they're the first group to score four triple platinum albums in a row from 1977 to 1981. *(Tommy Shaw, vocals/guitar. NIKON D3200, f/4, 1/200 second, 55mm, ISO 1600)*

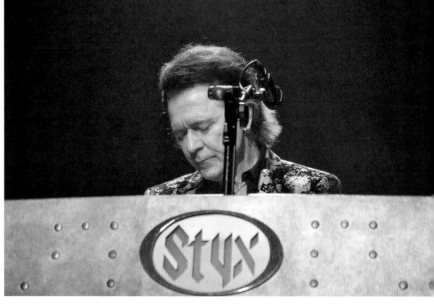

RIGHT—During the band's intermission, Gowan was by himself on stage, and was behind the keyboard with his back toward the crowd. He went into a Mozart-like solo galore that left people cheering. *(Lawrence Gowan, vocals/keyboards. NIKON D3200, f/4.5, 1/200 second, 92mm, ISO 1600)*

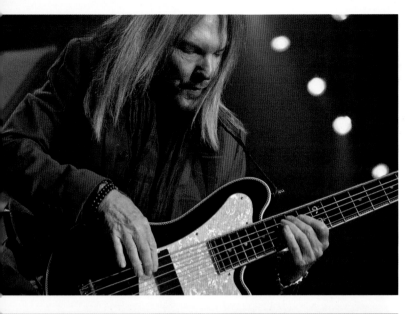

TOP LEFT—With a longer lens, you'll be able to get an extreme close-up. It may be a little complicated to get the person into the frame (especially when they're moving)—but when you do, the image will look like you were standing right next to them. *(Ricky Phillips, bass. NIKON D3200, ƒ/4, 1/200 second, 55mm, ISO 1600)*

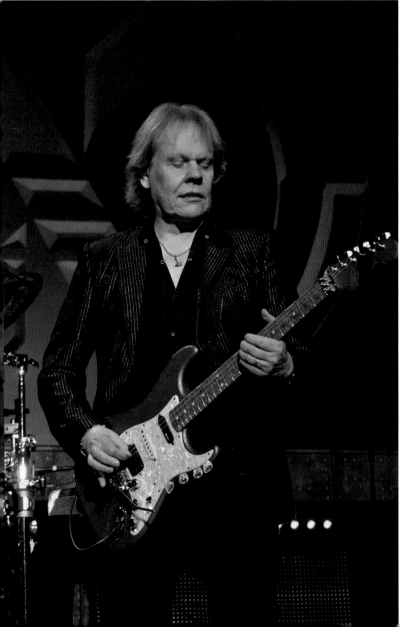

BOTTOM LEFT—Were they touring again as a way to receive that invitation to join the greats of the music industry in the Rock 'N' Roll Hall of Fame? "It's got nothing to do with what I do. I love what I do and I love getting on that stage and playing our music; and it brings me joy to do that . . . and whether or not we get voted in, it's not going to be the end of my world," James Young announced confidently. "But do we deserve to be in there? Of course." After watching them play live, I agree. *(James "JY" Young, vocals/ lead guitar. NIKON D3200, ƒ/4, 1/200 second, 55mm, ISO 1600)*

"With a longer lens, you'll be able to get an extreme close-up."

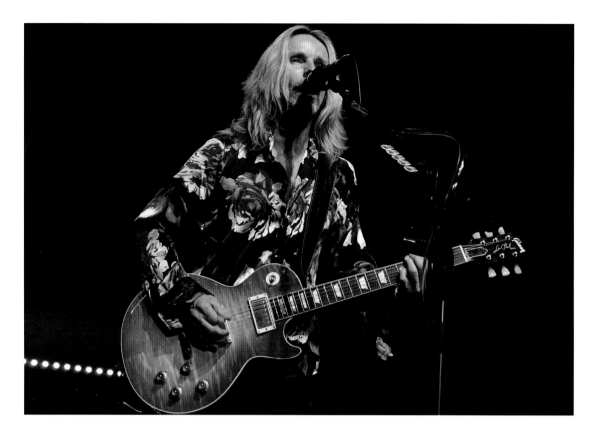

ABOVE—Just about every hit Styx has had was written by this guy. I'd say that he's had a great career. *(Tommy Shaw, vocals/guitar. NIKON D3200, f/5, 1/250 second, 365mm, ISO1600)*

BELOW—To work up the crowd during the intermission, Lawrence Gowan sang and played a snippet of Elton John's "Goodbye Yellow Brick Road" and then transitioned into the crescendo/choir part of Queen's "Bohemian Rhapsody." He instructed the crowd to sing along, and it turned out he was just priming us up for the epic Styx hit "Come Sail Away." *(Lawrence Gowan, vocals/keyboards. NIKON D3200, f/5.6, 1/200 second, 200mm, ISO1600)*

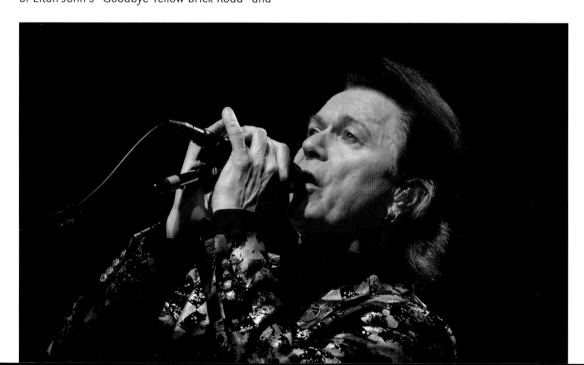

TRAPT

Fulton 55 in Fresno, CA | October 29, 2016

ABOVE—The best thing about music is the way it makes you feel. Trapt's seminal hit "Headstrong" was a locker room anthem among my football teammates. It's crazy how a song can transport you mentally to a point in time. Their performance did that to me. *(Chris Taylor Brown, lead vocals. NIKON D3200, f/4, 1/60 second, 22mm, ISO800)*

FACING PAGE, TOP—This may not have to do with photography, but if you wish to keep your hearing, I strongly advise you to wear earplugs. You're going to attend more shows than the average human and you'll usually be near the stage, in front of or next to the speakers, where you can feel the volume of the music hitting you. Protect your ears; they will thank you in the future. *(Brendan Hengle, drums. NIKON D3200, f/10, 1/60 second, 55mm)*

FACING PAGE, BOTTOM—Do whatever you can to not use the flash. I was starting out around the time these photos were taken, so I learned this lesson by trial and error. Even though you might get a good photo with flash, it's best not to distract the musicians. *(Ty Fury, lead guitar. NIKON D3200, f/8, 1/60 second, 18mm, ISO 320)*

> "If you wish to keep your hearing, I strongly advise you to wear earplugs."

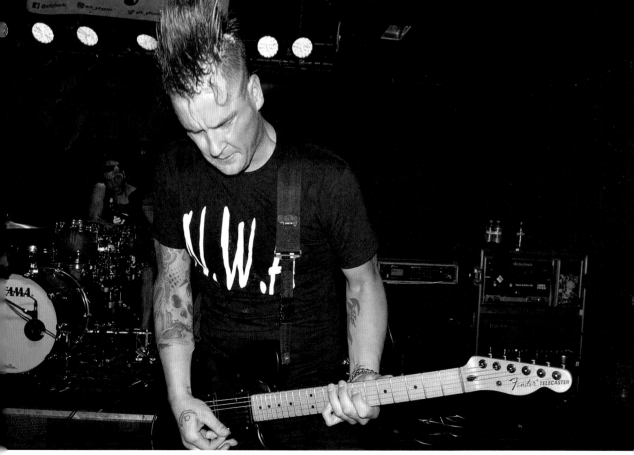

THE DEFTONES

*Woodward Park Rotary Amphitheatre in
Fresno, CA | August 23, 2016*

RIGHT—Going to these shows is a good way for you to network and meet new people. If you make a point of making some new friends who are also fans, you'll see some familiar faces at every show and you won't feel like you're there alone. Introducing yourself can also help advertise your brand. People meeting you and seeing you working with your camera can open up some opportunities to do other photography endeavors. *(Chino Moreno, lead vocals. KODAK Z650, ƒ/3.2, 1/160 second, 34.6mm, ISO160)*

BELOW—Cameras can be very expensive—but the talent you possess can't be bought. A high-priced camera may have some upgrades and new options that previous ones don't, and those can allow you to do more. But, in the end, you can't put a price on your eye and talent. Don't let the camera define you; let yourself become the camera. *(Chino Moreno, lead vocals. KODAK Z650, ƒ/3.3, 1/250 second, 47.7mm, ISO160)*

THE GUESS WHO

Tower Theatre in Fresno, CA | August 23, 2016

ABOVE—One of the pleasures of doing what I do is that I can photograph bands from different genres, ranging from classic to contemporary. I may not have them in their prime, but being there now is the closest thing I'll get to having that kind of experience. *(NIKON D3200, f/4.2, 1/125 second, 70mm, ISO 3200)*

RIGHT—Rudy used to play with Ozzy Osbourne, Quiet Riot, and Whitesnake. When I played high-school football in the mid-2000s, everybody else was listening to hip hop—but I felt like I could run through a wall whenever I played Quiet Riot! Rudy knows that feeling because he's a fan, too. "I've been a fan longer than I have been a professional musician. I've met some of my idols, and I understand the need for the fan to tell the idol how much their music means to them," shares Rudy. "To me, the ultimate outcome is for you to make something that makes an impact on someone."*(Rudy Sarzo, bass. NIKON D3200, f/4.2, 1/125 second, 60mm, ISO 3200)*

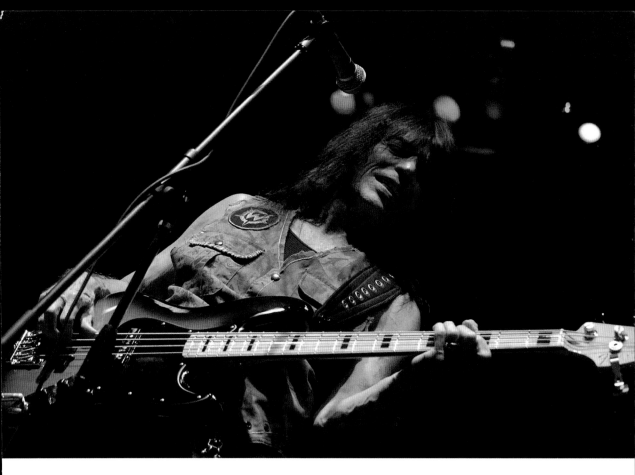

FACING PAGE, TOP—At big shows, there's a "media pit" where photographers and members of the press are allowed in a gated open area in front of the stage. When you're given access to this area, you can snap away with no one in your way. You can explore the stage to get the image you want. *(Derek Sharp [D#], lead vocals. NIKON D3200, f/5.6, 1/125 second, 55mm, ISO 1600)*

FACING PAGE, CENTER—In most small venues and clubs, there is no closed-off barricade for the media people. It's a free-for-all. You're just another spectator. That means you're going to confront people jumping up and down, dancing, and moshing—so you better have sturdy hands. I prefer to be front row at the stage so I have more room to work with and don't have to worry about hands or cell phones getting into my frame. *(Leonard Shaw, keyboard. NIKON D3200, f/5.6, 1/125 second, 52mm, ISO 1600)*

FACING PAGE, BOTTOM—Garry Peterson is the last remaining member of the original lineup. Capture these moments as best you can because you never know when these people will retire—and you can say you were there before they were done. *(Garry Peterson, drums. NIKON D3200, f/5.6, 1/125 second, 200mm, ISO 3200)*

ABOVE—For Rudy Sarzo, it was never about the fame. For him, music is spiritual. "I've always wanted to be a recording artist. I wanted to have a long career and I knew you couldn't have that extra baggage, drugs and alcohol—that's stuff you don't need," he advises. "It was my choice not to do it, and I had an epiphany before I joined Ozzy, where I found my spiritual center—and without it I doubt if I would've been strong when facing those temptations." *(Rudy Sarzo, bass. NIKON D3200, f/4, 1/125 second, 55mm, ISO 3200)*

Index

AmherstMedia.com

- *New books every month*
- *Books on all photography subjects and specialties*
- *Learn from leading experts in every field*
- *Buy with Amazon (amazon.com), Barnes & Noble (barnesandnoble.com), and Indiebound (indiebound.com)*
- *Follow us on social media at: facebook.com/AmherstMediaInc, twitter.com/AmherstMedia, or www.instagram.com/amherstmediaphotobooks*

Classic Rock
PHOTOGRAPHS FROM YESTERDAY & TODAY

Mark Plotnick and Jim Summaria present photos and text about rock and roll's legendary musicians. *$24.95 list, 7x10, 128p, 235 color images, ISBN 978-1-68203-410-1.*

Rock & Roll CONCERT AND BACKSTAGE
PHOTOGRAPHS FROM THE 1970S AND 1980S

Larry Singer shares his photos and stories from two decades behind the scenes at classic concerts. *$24.95 list, 7x10, 128p, 180 color images, ISBN 978-1-68203-292-3.*

Motorcycle Porn
PORTRAITS AND STORIES

Frank J. Bott shows you the sexy side of these beautifully engineered and adorned machines. *$24.95 list, 7x10, 128p, 180 color images, ISBN 978-1-68203-306-7.*

Inside Aviation Photography

Take wing with Chad Slattery as he photographs from the air and ground, photographing planes, pilots and more. *$24.95 list, 7x10, 128p, 180 color images, ISBN 978-1-68203-312-8.*

Big Cats in the Wild

Joe McDonald's book teaches you everything you want to know about the habits and habitats of the world's most powerful and majestic big cats. *$24.95 list, 7x10, 128p, 220 color images, ISBN 978-1-68203-324-1.*

Bald Eagles in the Wild
A VISUAL ESSAY OF AMERICA'S NATIONAL BIRD

Jeff Rich presents stunning images of America's national bird and teaches readers about its life and habitat. *$24.95 list, 7x10, 128p, 250 color images, ISBN 978-1-68203-328-9.*

Horses
PORTRAITS & STORIES

Shelley S. Paulson shares her love and knowledge of horses in this beautifully illustrated book. *$24.95 list, 7x10, 128p, 220 color images, ISBN 978-1-68203-330-2.*

Dogs 500 POOCH PORTRAITS
TO BRIGHTEN YOUR DAY

Lighten your mood and boost your optimism with these sweet and silly images of beautiful dogs and adorable puppies. *$19.95 list, 7x10, 128p, 500 color images, ISBN 978-1-68203-332-6.*

Owls in the Wild
A VISUAL ESSAY

Rob Palmer shares some of his favorite owl images, complete with interesting stories about these birds. *$24.95 list, 7x10, 128p, 180 color images, ISBN 978-1-68203-334-0.*

Polar Bears in the Wild
A VISUAL ESSAY OF AN ENDANGERED SPECIES

Joe and Mary Ann McDonald share images and stories of the bears' survival to educate and inspire. *$24.95 list, 7x10, 128p, 180 color images, ISBN 978-1-68203-336-4.*

AmherstMedia.com